Watercolor Basics:
People

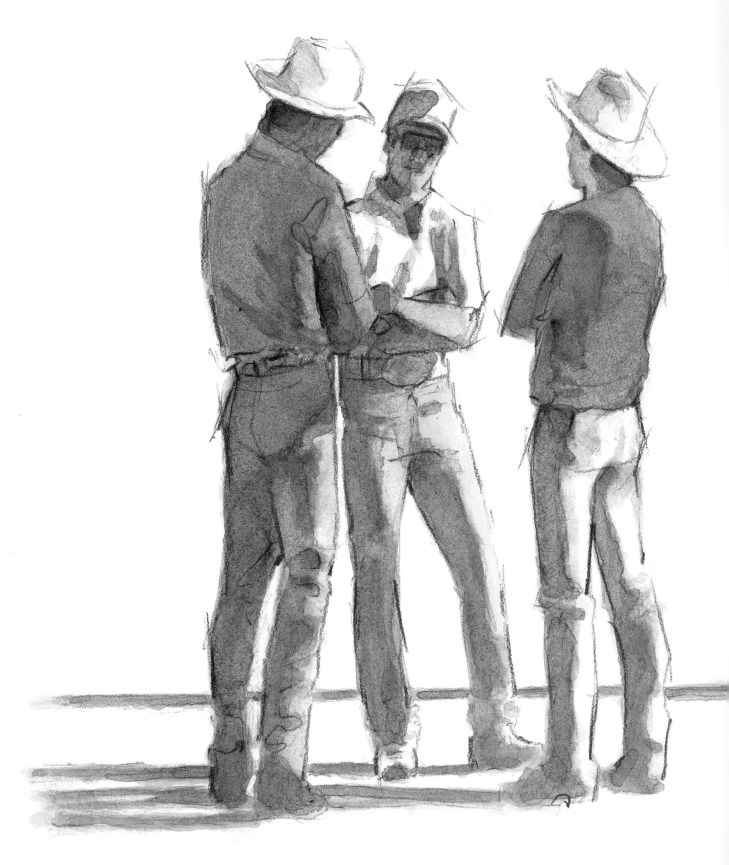

Four Men
8 ½" × 10 ½" (22cm × 27cm)

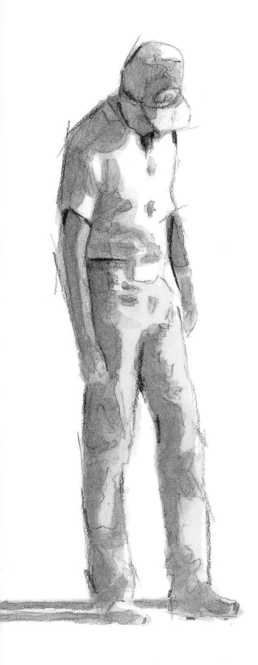

WATERCOLOR BASICS: PEOPLE

BUTCH KRIEGER

NORTH LIGHT BOOKS
CINCINNATI, OHIO
www.artistsnetwork.com

ABOUT THE AUTHOR

Butch Krieger has been a professional artist for twenty-eight years. His credits as an editorial illustrator include work for CBS, CNN, *PM Magazine*, AP, UPI, *USA Today* and the German publication *Neue Review*. As both an illustrator and a fine arts painter, Krieger specializes in portraiture and the human figure, as well as trompe l'oeil still life. His courtroom sketches have portrayed such dramatic scenes as the Seattle "Chinatown Massacre" trial, the Ron Lyle murder trial, the Utah radiation trials and the Crown Jewels of Hungary hearings. Several of his courtroom sketches are in the permanent collection of Brigham Young University's Museum of Art. His figure paintings and portraits hang in numerous private collections. Two of his portraits are included in Rachel Wolf's *The Best of Portrait Painting* (North Light, 1999). Krieger is a contributing editor for *The Artist's Magazine*.

A self-taught artist, Krieger holds a master of arts degree in political science from the University of California at Riverside (1973) and a master of arts degree in art history from Brigham Young University (1990). He is presently working on his doctorate in education from George Wythe College.

Krieger is originally from Los Angeles. He, his wife Yvonne and their five children moved his studio to a family farmstead near Port Angeles, Washington, in 1990.

Watercolor Basics: People. Copyright © 2001 by Butch Krieger. Manufactured in China. All rights reserved. No part of this book may be reproduced in any form or by any electronic or mechanical means including information storage and retrieval systems without permission in writing from the publisher, except by a reviewer, who may quote brief passages in a review. Published by North Light Books, an imprint of F&W Publications, Inc., 1507 Dana Avenue, Cincinnati, Ohio 45207. (800) 289-0963. First edition.

Other fine North Light Books are available from your local bookstore, art supply store or direct from the publisher.

05 04 03 02 01 5 4 3 2 1

Library of Congress Cataloging-in-Publication Data

Krieger, Butch
 Watercolor basics : people / by Butch Krieger.
 p. cm.
 Includes index.
 ISBN 1-58180-148-3 (pb.: alk. paper)
 1. Humna ficure in art. 2. Watercolor Painting—Technique. I. Title: People. II. Title:

ND2190.K75 2001
751.42′242—dc21 2001030485

Edited by Marilyn Daiker
Production Edited by Nancy Lytle
Cover designed by Joanna Detz
Production by Dan Craine

Metric Conversion Chart

to convert	to	multiply by
Inches	Centimeters	2.54
Centimeters	Inches	0.4
Feet	Centimeters	30.5
Centimeters	Feet	0.03
Yards	Meters	0.9
Meters	Yards	1.1
Sq. Inches	Sq. Centimeters	6.45
Sq. Centimeters	Sq. Inches	0.16
Sq. Feet	Sq. Meters	0.09
Sq. Meters	Sq. Feet	10.8
Sq. Yards	Sq. Meters	0.8
Sq. Meters	Sq. Yards	1.2
Pounds	Kilograms	0.45
Kilograms	Pounds	2.2
Ounces	Grams	28.4
Grams	Ounces	0.04

DEDICATION

I dedicate this book to my best friend and eternal
sweetheart—my wife, Yvonne.

ACKNOWLEDGMENTS

There are several people without whom I never
would have been able to do this book. They include
the publisher and extraordinarily competent
editorial staff at North Light Books—specifically
Rachel Wolf, Marilyn Daiker and Nancy Lytle. I
also owe this debt of gratitude to the design and
production staff at North Light. I likewise am
indebted to my friends Larry Ziegler and his associ-
ates at Camera Corner in Port Angeles, Washington,
and Jorge Simon at Abolins in Tacoma, Washington,
for their patience and photographic advice without
which I would have been unable to do the illustra-
tions for this book. I offer special thanks to the
models for my portraits who let me use their
beautiful faces for the demonstration paintings.
Finally I thank my family who tolerated me and
endured to the end.

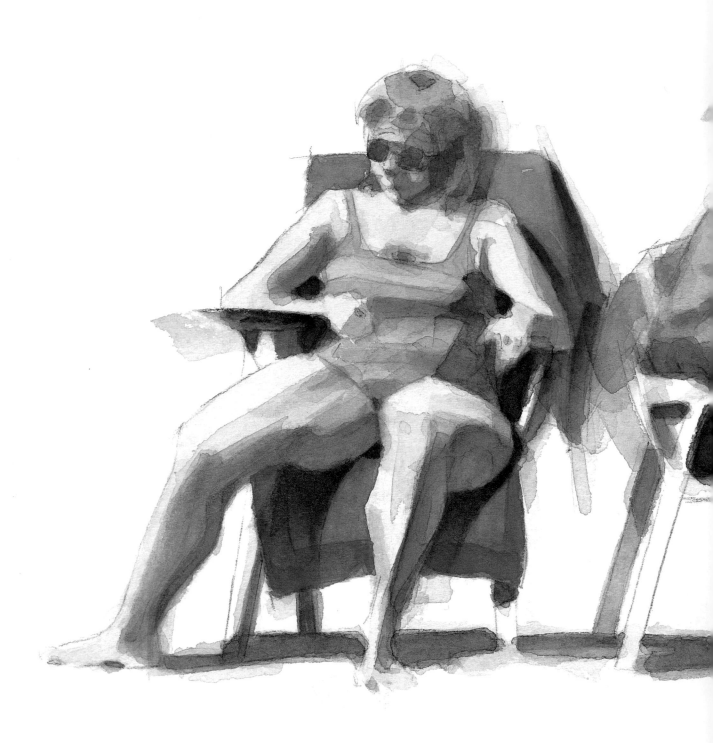

Swimmers
6 ½" × 10" (17cm × 25cm)

CONTENTS

KRIEGER

INTRODUCTION

Painting people and portraits, regardless of medium, is widely deemed to be the most difficult of all subjects in art. It is believed to be the hardest to get right. This belief is, fortunately, a fallacy. There is only one good thing about this misconception—a good thing that works to your advantage. When people see your work, they will be awestricken by it—and totally amazed that you were able to do such excellent portraits. Let them marvel. You don't need to tell them how easy it is.

My approach to teaching watercolor painting was inspired by the artists/teachers Betty Edwards and Bob Ross. Their ability to teach novices how to make beautiful art within a relatively short amount of time impressed me. Likewise, I have developed the method that I use in my classes and workshops. In this book you are my student. My objective is to teach *you*— a brand new beginner—how to do beautiful, delightful watercolor paintings of people. You will do paintings that are easy for you to do, but that, when finished, will look like they are the work of an experienced professional.

The biggest hurdle to overcome when you are learning how to paint people and portraits in watercolor is *fear*. It is the fear of failure that holds new artists back the most. Thus, as your teacher, one of my top priorities is to ease your fears.

The biggest key to reducing your fear is not within the painting process itself; it lies underneath the painting. It is the *underdrawing*—the preliminary, preparatory line drawing—that you do on your watercolor paper before you start to paint. The underdrawing blocks the forms out for you. It works as a map that guides you through the painting procedure and determines the anatomical proportions of the figure or portrait that you are painting as well as the placement of the various features.

In this book I dispense with that hurdle. I give you ready-made underdrawings from which you may do the portrait paintings. I teach you how to use the underdrawings to better control the painting process. I show you how to do your own successful underdrawings that you can use to do your own future portraits.

I have done everything possible to reduce your fear of failure. You will rely heavily upon the underdrawings to do each painting. This gives you more control over the painting procedure—and lessens the likelihood of failure. You also will use a painting method that reduces the risk of failure even more.

I have simplified the paintings for you. I have, for example, eliminated—or at least minimized—the background elements. This allows you to concentrate your attention and time on the specific subject of this book—people and portraits. The fewer things you must do in a painting, the less opportunity you will have to make mistakes.

I have chosen a palette of colors that I believe will work best for you as a beginner. Two of those colors, Rose Madder Genuine and Alizarin Crimson, are not lightfast. That means that, with the passage of decades, these colors will begin to fade. In about one hundred years they will have faded considerably. I have included these two pigments in your maiden palette for their excellence in blending beautiful flesh tones. Once you have learned to use this palette, you can explore the wonderful world of watercolor pigments and build a palette of your own.

Before proceeding to Chapter 1, I should explain the difference in meaning between the terms *people* and *portraits*. Technically, in the jargon of the artist, the word *people* is a synonym for *figures*, and *portraiture* is a specialized branch of figure art. The difference between painting people and painting portraits is a matter of focus.

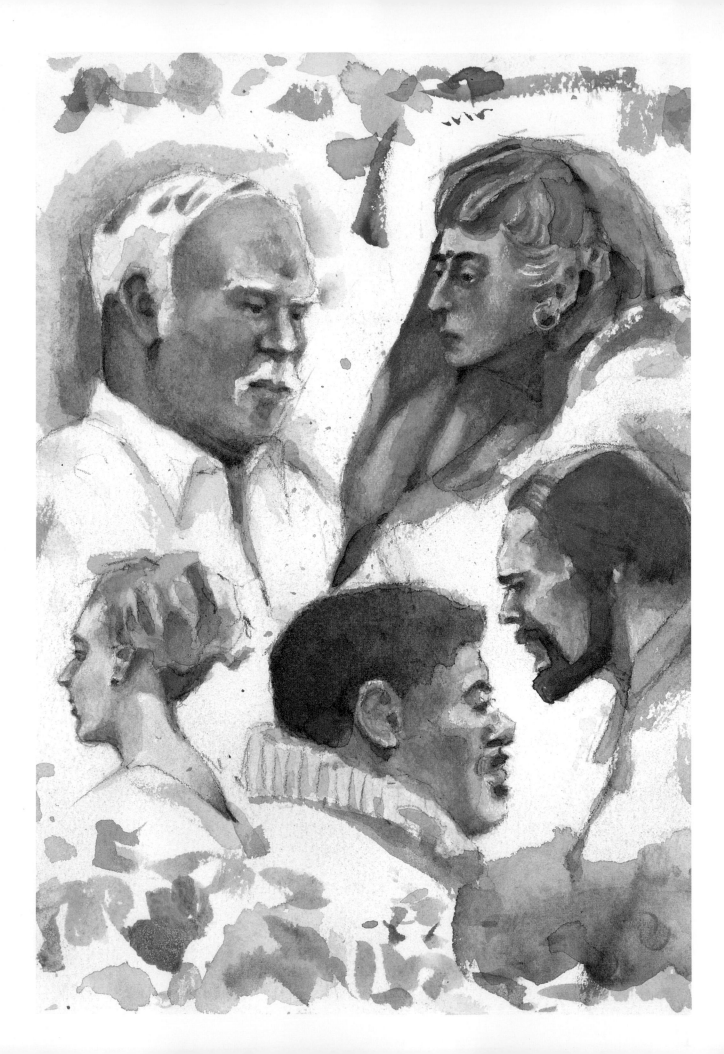

1

CHOOSE YOUR MATERIALS

I have tried to keep your expenses down as you embark on your adventure through this book. At the same time I want you to have the tools and supplies that will give you your best potential for success. You will see some brand names here. I do not have a deal with any of these companies; my only deal is with you. I have checked with each company, though, to make certain that these products will still be on the market for the foreseeable future. I will tell you about watercolor paints in the next chapter. The following are the basic tools and supplies—other than the paints themselves—that you will need for the exercises and projects in this book.

Brushes

The brushes an experienced watercolorist uses depends very much on the artist's personal style. If you are a beginner, you may have no idea yet what your style will be. You can get off to a good start with just six relatively inexpensive brushes. Unfortunately, brush size numbers are not standardized. They are not consistent from one brand to another—and sometimes within lines of the same brand. This list does, however, give you an idea of what to look for. If you already have good brushes that approximate those shown, they should do just fine.

You will need three pointed rounds. I recommend that your smallest be an Isabey series 6229 kolinsky retouching round no. 6. You will use this brush for the detail work that is so important in portraiture, so you should have a highest quality brush—one made with pure kolinsky sable. The resilient kolinskies keep their points better than any other kind, and they hold the most water. The Isabey retouching round is a short, slightly plump brush with a sharp point. Its full body will hold lots of watercolor and release it evenly as you use the point to render the

fine details. Even though this is a very fine brush, the no. 6 is small and therefore not as expensive as larger kolinsky brushes.

You will also want two other watercolor rounds: a medium-size brush and a large one. These, however, do not have to be the expensive kolinskies. You can substitute brushes selected from the economy lines that most major manufacturers offer. But please don't buy cheap off-brands.

You will need two flat brushes: a ¼-inch (6mm) and a ½-inch (12mm). These are useful for applying washes and broad strokes of color. You can use the flats to give your paintings that extra stylistic touch that can make your work look special.

You will also require one small round bristle brush—about a no. 2—or the smallest bristle round you can find. You won't use this brush to apply your watercolor to your paper or board (it is actually made for oils and acrylics) but will need it to lift up paint and remove it from the painting surface to model tonal values and make corrections.

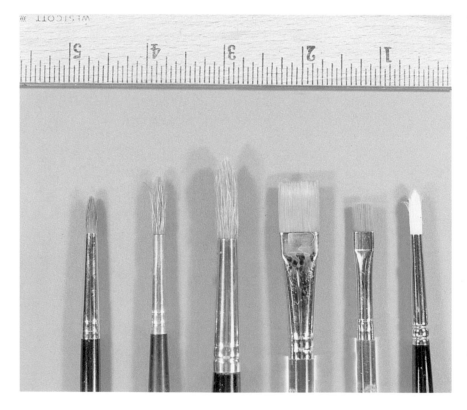

These are the brushes that I use for the demonstration exercises and paintings in this book. They are, from left to right: an Isabey series 6229 kolinsky retouching round; two Daniel Smith series 22-04 watercolor rounds, no. 6 and no. 10; two Daniel Smith series 72-99 Aquarelles, ¼-inch (6mm) and ½-inch (12mm); and a Daniel Smith series 30-11 hog bristle brush no. 2.

Ease Your Fears

First, do several experimental sheets *before* you attempt your first exercise or painting in this book. You will find that you will learn the best when you are working with just one concept at a time. The best time, for example, to learn to mix flesh tones is *not* when you are working on a portrait—especially not when you are working on your *first* portrait. *Everything* you do in a painting—whether it be color mixing, glazing, washes or whatever—should be something that you already know how to do. There are no exceptions to this rule—and no way around it. The best investment of time and money that you can make is in this preparatory practice.

When you do an actual painting, keep a "sacrifice sheet" alongside it. This is a piece of the paper or board that is identical to the one you are painting on. I never paint without one. With this sacrifice sheet you can pretest anything that you are about to do to the painting to make sure you've got it right. Let's say, for instance, that a flesh-tone mix looks too red, or perhaps too dark. With a sacrifice sheet you will discover the error *before* you put it on your painting. This will do much to reduce mistakes and keep you in control.

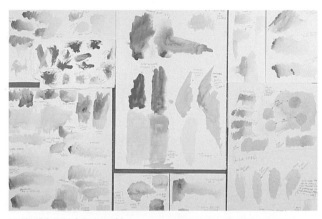

EXPERIMENT SHEETS

These are some examples of my own experiment sheets and boards. This is where my trial-and-error process takes place—where I test things such as colors, color combinations, color mixtures, surface textures and mediums. I don't like unpleasant surprises, so I never do anything on an actual painting that I haven't already tested and mastered on such a sheet. Notice, by the way, that I have written notes to accompany each test application. I never throw these away. These notes help to refresh my memory whenever I refer back to them.

SACRIFICE SHEETS

These are samples of my sacrifice sheets. I never work without a sacrifice sheet at hand. This will always be a piece of the same paper or board that I am using to do the painting. Here I test applications of paint before I use them on the painting. I try out washes, for example, to make sure they are neither too diluted nor not diluted enough. Sacrifice sheets are particularly useful to beginners because they can help you avoid unpleasant surprises that foster apprehensions and fear of failure.

Watercolor Paper, Board and Pad

For the exercises and projects in this book, you will need cold-pressed watercolor paper or board. I will use Crescent cold-pressed watercolor board. Even though designated *cold-pressed*, the surface of this board is smoother than most cold-pressed surfaces, which allows for the more delicate modeling and detailing of features that you will need for your portraiture. Fabriano Uno "soft-pressed" watercolor paper, which has a similar surface, is also an excellent choice for portraiture. If you do use the Fabriano, I recommend the 300 lb. (640gsm) because it is thick and sturdy.

You will need an Aquabee series 808 sketch pad. The sheets from this pad are the thinnest (60 lb.) watercolor paper that I know. It is even thin enough to run through some photocopiers. The pages of the 9" × 12" (23cm x 30cm) spiral-bound pad can be removed and trimmed to 8 ½" × 11", which is photocopy size. This will enable you to make additional copies of a preliminary drawing, which you can use as back-up or practice sheets. You can also convert a previous drawing, which you did on nonwatercolor paper, into watercolorable form.

There are other excellent watercolor supports. I particularly like Arches cold-pressed paper and Textured Claybord because of the wonderful textural effects that you can get with them. For now, however, let's keep things simple.

PHOTOCOPYING ON
WATERCOLOR PAPER
Prepare a 9" x 12" (23cm x 30cm) page from an Aquabee 808 watercolor sketch pad for photocopying simply by trimming it down to an 8 ½" x 11" (22cm x 28cm) sheet. I use a craft knife, but you can use scissors if you cut it very carefully and keep the edges straight and even. Be sure to remove the edge with the torn spiral holes because they will be a menace to the photocopy machine. You can use these sheets only in a copier that has a straight horizontal course and that can be hand fed. The texture of the paper is too rough to go around in the rollers without jamming it up. Any photocopy shop should have at least one copier like this.

Easels

I don't recommend that at the very outset you spend your hard-earned money on a large expensive easel. You do not need a big full-blown studio easel to learn the basics. You have other options that are much simpler and much less expensive. A piece of hardwood (also known under the brand name Masonite) and a big clip will work well. Most major art supply stores have boards that are made specifically for watercolor painting. Another option is a Tote Board, which is a fashioned hardwood panel with a hole that serves as a handle and a built-in clip. Anything like this should do just fine—whether at home or away.

When you are ready to buy an easel for your portraiture, it will probably be your most expensive investment. This purchase, therefore, merits some serious consideration. Here are the things you should look for in a portable easel. The easel surface (the part that the painting actually lies against) should be wide and flat. This will allow your paper to lie flush against it so that your painting won't give or teeter while you are working on it. The easel should be convertible; i.e., it should tilt up for the drawing and detailing phases of your portraits but lay down horizontally for applying watercolor washes. The easel should have telescoping legs. This will allow you to adjust the length of each leg to make sure that the painting surface is perfectly horizontal, especially when painting out in the field. If your painting is not completely horizontal, your washes will not spread and dry evenly.

My travel rig is a Savoir Faire French Box (Safari All-Terrain) Easel. This is the only portable easel that I consider suitable for painting people and portraits in watercolor. The Safari can also serve as a studio easel and, because the legs fold up inside the box, you can use it as a tabletop easel as well.

If your heart is set on a full studio easel, a good economical option is the Collegiate Lobo by Best. This low-price beginner's easel is made of hardwood. It is, nonetheless, just as sturdy and durable as the fancy furniture-like models made of fine wood. The Lobo, unlike most other easels, can fold up flat. This is particularly convenient if your studio is also your kitchen. There are, of course, several larger and more costly models on the market. A studio easel will not likely have a flat, flush surface. When you are painting on paper or watercolor board, therefore, you may have to lay a piece of hardwood board (or something similar) across the front of it. Just be sure that the easel you get is convertible, or it will be of little use for watercolor painting.

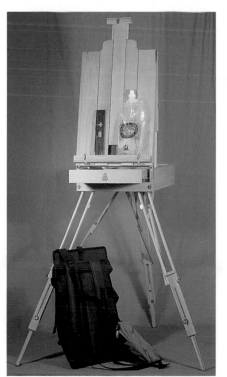

TRAVEL LIGHT AND KEEP IT SIMPLE
This is my portable rig—a Savoir Faire French Box Easel that I use for watercolor portraiture when away from my studio. It folds up to become a box I carry in the backpack (called a Studiopak) that you see underneath it. The flat plastic bottle that you see on the easel's face is a Platypus. This water source (I use only distilled water) fits into the easel box. The object next to the bottle is a small carpenter's level. I use this tool to make sure that the painting surface is always perfectly horizontal when I lay the easel top down to apply my washes. This is particularly important when painting outdoors, where the ground is not always even and flat. If the ground is not level, I can adjust one of the telescoping legs to compensate for it.

Miscellaneous Supplies

Palette

You need a white watercolor palette that you can buy at any art store. The exact brand or type is not important. Just make sure that it has wells for each color and a bigger area for color mixing. You should have *two* containers for your water: one for rinsing and cleaning your brushes, and a separate one of clean water that you will use to paint. Also keep facial tissues and paper towels or rags at hand for blotting, dabbing and/or wiping.

Surfactants and Granulation Mediums

These are additives you can use to change the appearance of diluted watercolors when you apply them to supports. A surfactant—also known as a *flow release* or *flow improver*—reduces surface tension on your support. This simply means that the water-based paint spreads more easily across the surface. Use it to model facial features in your portraiture without an unpleasant build-up of rim lines. These lines form around the edges when an application of

watercolor solution dries. This is not ordinarily a problem—the lines often create a desirable effect—but when unwanted, a single rim can be softened with a brush and some clear water. When modeling facial features, however, the rim lines can accumulate and become unpleasantly cluttered. And removing them can be a problem when several of them are clustered in the middle of a face. The surfactant will prevent this rim-line buildup, which will allow you to be more cautious in your modeling. This will reduce the odds of your making an error and help alleviate your fear of failure. Winsor & Newton, Golden and Daniel Smith all manufacture surfactants. Originally intended for use with acrylic washes, they can be used with watercolor as well.

The granulation medium causes the pigment in a watercolor wash to settle at the bottom of the puddle. This results in a grainy appearance that you can use to create some delightful textural effects. In one of your projects in this book, for example, you will use it to get the appearance of a fluffy, furry collar.

TAKING THE EDGE OFF

This shows you how a surfactant works. I diluted the paint on the left with plain water; I did the other one with a few drops of surfactant. Both dried under the same conditions. You can see the difference. The surfactant caused the watercolor's pigment to disperse more evenly, giving it a smoother appearance and a softer edge. The effectiveness of this medium may vary with different pigments and on different surfaces. Moreover, when you first try a surfactant, a brushstroke may surprise you and spread out more than you expect. So experiment with it first. A little practice will bring it under control.

GRANULATION

This is how granulation medium works. Compare the dried wash on the right, which has no granulation medium, to the one on the left. You can use this technique to get a wide variety of textural effects. The medium works much better with some pigments than it does with others. So just remember to experiment with it before you use it in a painting.

Liquid Frisket

This is a solidifying fluid that you will use to mask off areas that you want to keep white when applying your washes. When the wash is dry, you just peel the frisket off.

Pencils

A no. 2 pencil will work just fine for your preparatory drawings. Don't use a drawing pencil softer than a 4B, though, because it will smudge. If you are heavy-handed or sloppy, even this may be too soft. Just keep your pencil sharp so that you draw crisp, clean lines. A kneaded eraser is the best choice for correcting mistakes.

Additional Tools

A small carpenter's level will come in handy to make sure your painting is perfectly level when laying in a wash. If it is not level, your wash will gravitate to one side or even run across your painting. You can find small levels at any hardware store.

While you are at the hardware store, pick up a roll of masking tape. There will be some times when you will have to tape down your paper to keep it from buckling. Art stores sell tape that is especially made for this purpose. Either one will do.

Vanishing Image Paper

If you have little or no experience with watercolor, I urge you to purchase a sheet of Holbein's Vanishing Image Paper. This is a piece of paper on which you can practice your brushstrokes. You can use and reuse one sheet indefinitely, because you apply just plain water. When the water touches the sheet, the brushstroke turns the surface dark. As the water evaporates, though, the brushstroke disappears. Brush method is particularly critical in portraiture. You must be willing to practice as much as it takes to learn your technique *before* you start on an actual painting because it will give you better control over the brush. This, in turn, can increase your self-confidence—and thereby decrease your fear of failure.

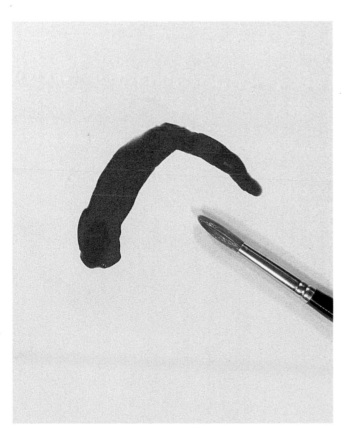

PRACTICE MAKES PERFECT
This is what Holbein Vanishing Image Paper looks like. The surface area that is wet has turned black, showing us the shape of the brushstroke. When the water dries, the stroke will completely vanish. This enables you to practice your brush technique for as long as you need without wasting several sheets of expensive watercolor paper or board. Just remember to use only pure water, or you will permanently stain the paper.

Proportional Divider

This is a small technical instrument that may improve the accuracy of your portraiture. Most proportional dividers are quite pricey, but there is an inexpensive plastic model on the market with the brand name Prospek. This device will help you get your proportions and placements right when working from either a photograph or from life (See page 55).

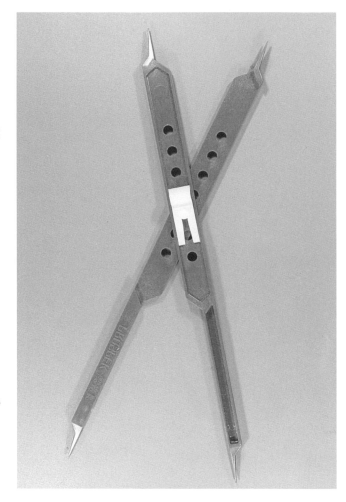

KEEP THINGS IN PROPORTION
Proportional dividers are usually made of mostly metal and are quite expensive, but this plastic model works just as well at a fraction of the cost. It can help you to keep your proportions consistent and to place facial features more accurately in your portraits.

My Pocket Studio

Everywhere I go, I carry what is called a "spit palette." This is an artists' name for a small watercolor traveling kit. My spit palette is a Winsor & Newton field kit that fits into my fanny pack. I always have it with me, because I never know when I might see some irresistibly fascinating sketchable face or figure. This is the setup that I used to do the little supplemental watercolor sketches that you see in this book. None of the people in these paintings were posing for me. They didn't even know that I was sketching them. This tiny size allows me to be inconspicuous while I do these colorful little vignettes.

The Winsor & Newton field box includes a small water bottle, a brush and mini-palettes. The half-pans of dry watercolor are all either Winsor & Newton or Sennelier. (The kit comes with twelve half-pans, but I have my own array of fourteen colors.) The gray wad that you see in the top middle is a piece of kneaded eraser. The brush closest to the box is the one that comes with the kit. The one next to that is a Daniel Smith travel brush no. 4. The third one is an Isabey 8202 miniature squirrel quill mop. All three of these traveling brushes are *collapsible*, which means that the removable handle doubles as a protective cap.

I also carry a pad of fifteen blank 4" × 6" (10cm × 15cm) postcards printed on 140-lb. (300gsm) watercolor paper. This is the most economical type of watercolor paper that fits into my fanny pack right along with the field box. Sometimes I take along an Arches 10" × 7" (25cm × 18cm) watercolor sketch book that contains fifteen sheets of 140-lb. (300gsm) cold-pressed watercolor paper. I carry my favorite pencils (Ebony Jet Black Extra Smooth) in my shirt pocket.

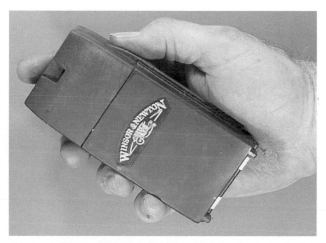

This is my Winsor & Newton field box mini-rig, photographed in my hand so that you can see how small it is.

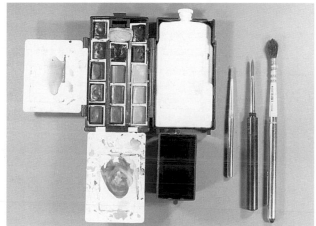

In this photo, I have opened out my pocket mini-rig for you to see everything inside it.

Lauren
5½" × 3¼" (14cm × 8cm)

CHOOSE YOUR PALETTE

In this chapter, we will do four things. I will, to begin with, give you a list of colors to use for the exercises and paintings in this book. You will learn how to use your experiment sheets. This is where you will acquaint yourself with each of the colors on your palette *before* you use them in any actual paintings. You will also learn the basic principles of rendering human skin, as well as the modeling of human forms. And I will recommend some other good flesh-tone colors for you to try when the time comes for you to expand your palette.

Flesh-Tone Colors

We will be using a very streamlined choice of colors that I call a *human palette*. A human palette is a strategic system of pigments that is specifically geared to flesh tones. It is aligned with the primary colors (red, yellow and blue), which are the fundamental components of all skin colors. I originally developed this system for my watercolor field box (see page 19) for expedience and speed. You will be using a modified and simplified version of it that will require twelve tubes of paint: Rose Madder Genuine, Alizarin Crimson, Quinacridone Sienna, Burnt Sienna, New Gamboge, Quinacridone Gold, Yellow Ochre, Raw Umber, Cobalt Blue, Ultramarine Blue, Indanthrone Blue and Burnt Umber.

This will give you four reds, three yellows and three blues. The two browns, the Raw Umber and the Burnt Umber, will serve as convenient ready-made dark blends.

This restricted palette will simplify things for you, when you are first learning to do flesh tones. After you have developed your color judgment, you can expand your repertoire to include a wider variety of colors.

Such a focused palette can also teach you to think of flesh tones in terms of the three primary colors. Later, when you begin to expand your palette to include the secondary and tertiary colors, think of them as ready-made mixtures of the primary colors.

Looking Ahead

There are many wonderful pigments on the market. The spicy quinacridone colors, for example, make excellent flesh tones—especially when you are painting the effects of skin out in bright sunlight. We use two of them, Quinacridone Gold and Quinacridone Sienna, in this book. Other good examples of quinacridone colors are Maimeri's *Avignon* Orange and Golden Lake, and Sennelier's Chinese Orange.

There are many beautiful earth colors available in addition to the four that we use here (Raw Umber, Burnt Umber, Burnt Sienna and Yellow Ochre). The earth pigments are refined from ore that is extracted from mines, and they make wonderful flesh tones. Some of them will even render natural-looking skin colors right out of the tube, without having to mix them with other colors. They usually have names that include words such as *earth*, *umber*, *sienna* (except Quinacridone Sienna) and *ochre*. There is a wonderful world of flesh-tone colors just waiting for you when you are ready to expand your palette.

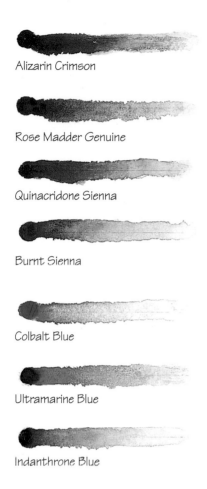

Alizarin Crimson

Rose Madder Genuine

Quinacridone Sienna

Burnt Sienna

Colbalt Blue

Ultramarine Blue

Indanthrone Blue

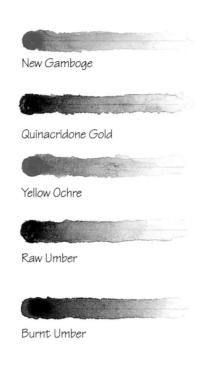

New Gamboge

Quinacridone Gold

Yellow Ochre

Raw Umber

Burnt Umber

These are our colors. I have arranged them into groups of the three primary colors and browns. When you have your own tubes of these colors, make this chart for yourself. Then study the colors closely, observing that different colors have different temperatures. Notice that the reds and yellows look warm; the blues look cool. It is almost as if you could feel the temperature differences if you were to touch them with your fingertip. Note too that temperatures can vary even within a group of primary colors. The slightly bluish Alizarin Crimson, for instance, is cooler than the Rose Madder Genuine. The orangish Quinacridone Sienna, on the other hand, looks warmer. As you will see later in this book, this warm/cool distinction is fundamental when making flesh tones.

Suppliers

In some cases, I have specified the brand names of paints that you may want to add to your palette. This is because most watercolor manufacturers have some colors that are uniquely and exclusively theirs, and you can't get them from anyone else. You may be unfamiliar with some of these brands, and not all local art stores carry every line. Here is a list of each manufacturer/distributor (in alphabetical order) along with its telephone number(s) and Web address. Each company has a list of all its retail outlets and can tell you which store is closest to you.

Daniel Smith
(800) 426-6742
(206) 223-9599 (international calls)
www.danielsmith.com

Holbein
(888) HOLBEIN (888-465-2346)
(802) 862-4573 (international calls)
www.holbeinhk.com

Maimeri
(pronounced "my Mary")
(888) MAIMERI (888-624-6374)
(847) 678-6845 (international calls)
Maimeri's Italian Web site is
www.maimeri.it

Sennelier *(the 'r' is silent)*
United States distributor:
Savoir Faire
(800) 332-4660
(415) 884-8090 (international calls)
www.savoir-faire.com

Winsor & Newton
(800) 445-4278
(732) 562-0770
www.winsornewton.com

Transparency and Earthiness

Each of the pigments on this palette has at least one of two characteristics that lend themselves to making flesh tones. The first of these is transparency—or at least semi-transparency (also called *translucency*). Whereas some pigments are inherently opaque or semi-opaque—such as the extremely dense cadmium colors—others are inherently transparent or translucent.

I prefer the more transparent pigments because they produce luminous flesh tones. Even in heavier applications, they allow the pure white surface of the paper or board to show through. A glaze of a transparent pigment will also allow earlier layers of other colors to show through. And this is what gives watercolor paintings their vividness, particularly in the flesh tones.

As a beginner, you will enjoy benefits from the more transparent pigments. They will help you to build up flesh tones cautiously by building up thin layers of glazes. Layering colors one on top of another will help you to avoid the muddiness that can result from mixing too many pigments directly into each other.

Earthiness is the second characteristic of these colors. The earth pigments themselves—the umbers, Burnt Sienna and the Yellow Ochre—make strikingly realistic and lifelike flesh tones because they tend to look like the colors of flesh to begin with. Although they are not all as transparent as the other colors on this palette, they are not too opaque for our purposes here.

I will, for the sake of consistency, be using one brand of tube watercolors—Daniel Smith. This is the only manufacturer of Quinacridone Sienna, and one of only two companies that I know of that make Indanthrone Blue(The other is Winsor & Newton.). You may already have some of the recommended colors in other brands, which you may wish to substitute for the ones I use here. Keep in mind, though, that colors are not standardized throughout the industry; they can vary from one manufacturer to the next. So if you use a different brand of watercolors than the one I use here, you can expect to get slightly different results.

There is one minor disadvantage to the human palette: It doesn't include any of the secondary and tertiary hues. We will have to mix them from our three primaries. This will limit our choices of oranges, violets and greens. Working with just the human palette, though, will help you concentrate on the most important challenge that you have right now—making credible flesh tones.

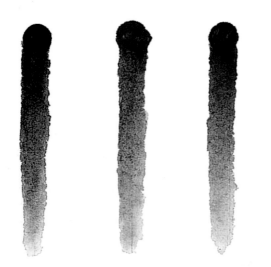

Colors with the same or similar names are not necessarily interchangeable. The comparison at left shows you what I mean by this. On the left is Daniel Smith's Raw Umber, which I am using in this book. Next to it are Holbein's and Winsor & Newton's Raw Umber. You can see that they are not the same. If they did not have the same name—Raw Umber—you might not even know that they were all the same pigment. This is not a matter of right vs. wrong—or of which brand is the best. All three are excellent colors. I use each of them myself, although I treat them as separate and distinct colors. My point is that you should never assume anything about the color of your paints. You don't want any displeasing surprises. This is particularly true when dealing with flesh tones, where the balance of hues is so essential.

Using Your Experimentation Sheets

This is how you familiarize yourself with the colors on your palette. For demonstration purposes, we will be testing just three of our colors—Rose Madder Genuine, New Gamboge and Cobalt Blue. First, lay your paper or board down flat. Then place a dab of each of these colors in a row. Be sure to keep the three dabs close to each other so that you can see how they look together. This is important because color perception is relative. A color's appearance will, in part, depend on the other colors around it. So even if you have already tested out any of these paints individually, do them again *together*.

With a medium-size brush, deposit a small puddle of clean water beneath the first dab of paint. Then use your brush to pull the water up into the paint and back down again—dragging some of the paint back into the water. Now repeat the process with the other two colors. This process, called *letting it down*, will show you what each color will look like when you use it. (See step one below.).

In step two, you want to see what each color will look like when mixed with each of the other colors. On your paper or board, put a dab of the Cobalt Blue and a dab of Rose Madder Genuine about 1 inch (25mm) apart, with a small puddle of clean water beneath them. Then bring the water up to each of them and pull them down into the water and into each other. Repeat the process with the Cobalt Blue and the New Gamboge, as well as with the Rose Madder Genuine and the New Gamboge. Now study the resulting violet, green and orange. Observe that the orange, when diluted, will serve as a good pale-Caucasian flesh tone. Remember that it does not have to be an exact duplicate of anyone's actual skin color—but a plausible approximation of a typical light-Caucasian's flesh tone. The key word is *credibility*. This will make a credible flesh tone. We can now add this mixture to our repertoire of base flesh tones.

STEP ONE

When you paint with watercolor you will usually dilute it first. Thus, seeing its hue in just its concentrated form will not show you what it will look like when you use it. The very first thing you should do with a new tube of watercolor is to let it down with water, such as I have done here with the Rose Madder Genuine, New Gamboge and Cobalt Blue.

STEP TWO

Here I have drag-mixed each of my three colors with each of the other two. The red and blue blend well to give a beautiful violet that we can use for cool shadows. The pleasant green will make a perfect eye color. Now look at the orange mixture; it is a bit too drab to work as a good orange—but it dilutes to become a useful light-Caucasian flesh tone.

Understanding and Discerning Flesh Tones

The term *flesh tone* has two meanings for the artist. In one sense it refers to the color that we see on the surface of actual human skin. There are two types of flesh tones: *base tones* and *augmentive tones*.

The base tones are the skin colors with which we describe people's appearance—such as black, white, swarthy, brown, ruddy, ivory, olive, etc. There are two sources of this color. One is pigmentation. There are two kinds of pigment: melanin and carotin. Carotin is the main skin pigment of people of East Asian descent; melanin is the main pigment of most other people. All flesh tones—except that of albinos—will have one or both of these pigments in prominence.

The other source of skin color is blood. Blood can be blue. If you study the back of a light-Caucasian man's hand and forearm, for instance, you may see some blood veins showing through. As it filters through the skin, which is basically an orange color, the blue blood will look grayish. Most of the blood that shows through the skin, however, is red. You will likely see lots of it on the knuckles. On the face, you may see more of it across the upper cheeks and nose (the *color bar*) and on his ears.

The augmentive tones are the external, fleeting hues that result from the interrelationships of colors and the interplay of light and color that move on the surface of the skin. The augmentive tones, because of their subtlety, usually go unnoticed by the untrained eye.

To the artist, the term *flesh tones* refers to the colors used to paint the appearance of human skin. In conversations about painting people and portraits, you may hear the phrase *true flesh tones*. This usually refers to the easily recognizable intrinsic base colors. But it is important to understand that even the base tones are not fixed and constant. They are actually quite variable—even within one individual. The color of one's skin surface differs based on quality of light. In order for your painted flesh tones to be "true," it is only necessary that they look characteristic and natural within the overall color context of your painting. In other words, flesh tones are less precise—and thereby easier to match—than you thought they were.

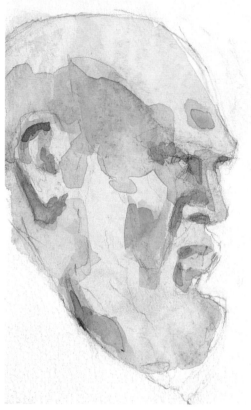

This is a small 4" × 6" (10cm × 15cm) unfinished field sketch that I did of someone who did not know that I was drawing and painting him. The very orangish color—a mixture of Rose Madder Genuine and New Gamboge—is not a natural skin tone at all. Yet it works just fine for a quick sketch. Flesh tones can be much more flexible than one might expect. Observe how I applied the varying monochromatic tonal values of the paint to help produce the illusion of a three-dimensional form.

Making Flesh Tones

In this book, I will show you some flesh-tone mixtures that can give you a jump start on painting people. In the long run, though, you will need to master flesh-tone mixing by your own eye. Here are four keys that will help you get natural-looking flesh tones.

Instinct

You have an innate sense of flesh-tone perception. Whenever you see a color (or color combination) that looks like a base flesh tone, it triggers a psychological response from you. You will intuitively recognize it as a skin color—and it will please you to look at it. You have probably already experienced this response when you have seen a portrait painting that had natural-looking skin colors. Your mind is programmed for this response—and you can let it be your guide to painting flesh tones. In other words, learn to rely on your flesh-tone intuition.

Experimentation

The successful creation of flesh tones requires an intimate and thorough knowledge of each of the pigments on your palette. And the only way you can gain such knowledge is by experimentation. You must know firsthand what each of your colors will look like when mixed with each of the other pigments on your palette. I cannot really overestimate the importance of doing this. The willingness to commit the time and effort to experiment is one of the things that separates the skilled artist (whether professional or serious amateur) from the unskilled.

The time to conduct your experiments, though, is not when you are doing a painting. This would be the worst time to discover, for instance, that a flesh-tone mixture does not produce the results that you had anticipated. All questions should be resolved *beforehand*. (This is what your experiment sheets and boards are for.) Ignoring this rule may well result in disappointing failures.

Observation

If you want to paint good flesh tones, you must first train yourself to see them. Train yourself to look for those oftentimes faint changes of color and tonal values that occur across your subject's skin as it undulates in and out of the light. Observe the transitions of color that happen when the skin surface begins to turn away from the main source of light and enters into the domain of reflected light. This is where you will find many of those exciting augmented colors that can bring a portrait to life. These things may be subtle—but if you search for them, you will find them.

Artistic License

This is the most fun and exciting part of doing flesh tones. You, the artist, are at liberty to intensify—and even to abstract—all the nuances of color that you see before you. You can improve upon nature. And what is more, you can dispense with the "true" flesh tones entirely and replace them with whatever color scheme you wish. So loosen up a little—and you will have more fun.

Hair and Eye Colors

The chromatic principles for painting hair and eyes are the same as those for painting flesh tones. All hair and eye colors are derived from one or more of the three primary hues. And like the base flesh tones, hair and eye colors are not constant and fixed, but will vary according to the quality of light in which you see them.

A Word of Encouragement

There is one more thing you should keep in mind as you strive to paint the colors of human beings: It is a struggle only at the beginning. Within a short time making flesh tones, as well as hair and eye colors, will become second nature to you. It will be something that you can do—and do well—without a second thought.

Tonal Value Scale

Explore the possibilities of the fleshlike orange combination mixed from the Rose Madder Genuine and New Gamboge by building a nine-step tonal-value scale to discover how the mixture will look at its different values—from the very lightest to the very darkest. On 300-lb. (640gsm) Arches cold-pressed paper, use a pencil to block out the scale band in the form of a long rectangle. Then divide the rectangle vertically into three sections.

Mix up a generous puddle of the base flesh-tone blend on your palette. Test it on your sacrifice sheet to make sure you have just the right combination of the red and blue. Take a few drops of it to the side and make a second puddle by diluting it with water. This gives you the initial wash that you apply uniformly across your flesh-tone band.

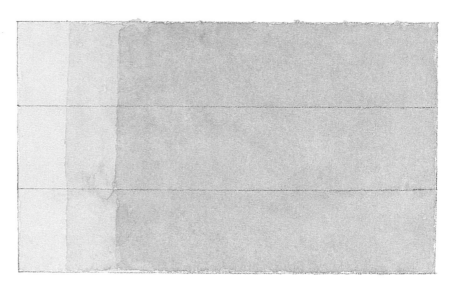

After the first wash has dried thoroughly, begin developing the scale further. Layer another wash over the first one, stopping about one-half inch (1cm) to one inch (2cm) short of the left edge. (If you are left-handed, you may want to reverse this.) Repeat this stage, continuing to stop just short of the endpoint of the previous wash. Thus you build up values on one end of the band by gently adding subsequent applications of the wash. Always make sure each application of paint is completely dry before you add the next. Be very cautious and use very light washes. If you discover that a previous application of paint is now too light, go back and layer another wash over it. When the glazes begin to accumulate, take care not to lift up previous layers by scrubbing them with your brush. As you go along, occasionally add more of the initial paint mixture to the wash puddle to make it darker.

Here is a nine-step flesh-tone scale that shows the practical limits of the flesh color's capability.

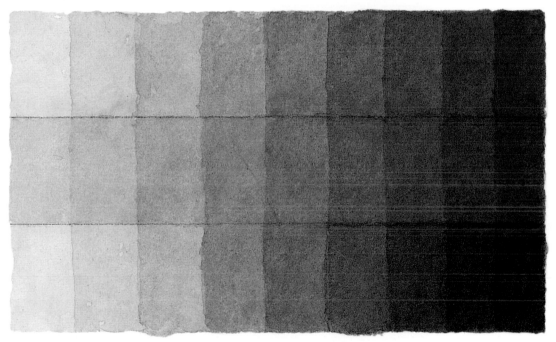

We can now explore our flesh tone's possibilities a bit further by glazing over it with varying layers of its color complement: Cobalt Blue. Leave the top section of the band as it is, without modifying it. In the next section, use a light glaze of the blue to evenly cover the entire length of the band. In the third section, use the blue to darken the lower values of the scale. Having done this, we can see that the blue will not only darken the flesh tone even more, but also will neutralize it and tone it down. (I should mention that I could have extended the scale a step or two darker, eventually making the bottom-right corner look virtually black. But I don't want you doing that yet. It can wait until you have had more experience.) We can now use this scale as a permanent reference chart. And we also know how to make such charts with other red-yellow-blue combinations.

CAPTURE THE MOMENT

Every time you apply a brushstroke of watercolor to a painting, you must make at least four decisions. You must decide *where* on the surface of your board or paper you will put the paint. You must decide *how* to put it there, such as which kind of brushstroke to use. You must decide *which color* you will put there, and you must decide *how much* of that color that you are going to put there. This is too many decisions for a brand new watercolorist to make simultaneously. Every time you touch your brush to the board, it quadruples your risk of making a mistake, thereby increasing your fear of failure. So to make it easier for you, I will show you how to make each one of these decisions at separate stages in a painting's development. This will enable you to deal with just one concept at a time.

In this chapter, you will learn how to make the first of the four decisions: *where* to put the paint. You will learn how to do the under-drawings for your watercolor paintings. An *underdrawing* is a pattern of pencil guidelines that you draw directly on your painting surface before you do the actual painting. This framework serves as a map of the major landmarks that will later guide you as you apply the watercolors.

Portrait of Chuck Fuchser (Version 2)
10" × 7½" (25cm × 19cm)

31

Underdrawings

In my demonstration underdrawings, I use lines that are very prominent and bold. This will help you see them better. You, however, need not make your guidelines so dark. I will use a graphite pencil. My pencil of choice is an Ebony Jet Black Extra Smooth, which has a medium-soft lead. You can just as easily use a regular no. 2 pencil, which is not so dark. Either way, just be sure to keep your pencil sharp and to draw with a light touch.

You will use the underdrawings that we do here to do the demonstration paintings in chapter 5. You will learn how to extract the images from the photographs that you will translate into the underdrawings. I have selected these photos with you in mind. I have chosen them because they are relatively easy. Moreover, I picked these photos because they exemplify the challenges that you will encounter when doing future watercolor paintings from your own photographs.

Convert Existing Drawings

In this chapter, you will also learn how to convert preexisting drawings—drawings that you may have already done on regular drawing paper—into "watercolorable" form. I have done this because, so many times, students have shown me drawings that they have already done on regular drawing paper, from which they would like to do paintings. I myself have often converted such pencil sketches into watercolor paintings. As with the photographs, I have selected drawings that typify the challenges of translating a drawing into a watercolor painting.

True to the promise that I made you in the introduction to this book, I am giving you very simple images for your watercolor projects. In both the people painting and portrait chapters, I have minimized the cluttering details that surround each figure or face by either minimizing the background or even omitting it entirely. This will enable you to focus your attention on the people themselves.

Drawings Vs. Underdrawings

An underdrawing is different from a regular drawing. Below left, for example, is an impromptu sketch of a dancer that I drew from life. In the middle is an underdrawing that I did afterwards from that sketch. And on the right is the watercolor painting that I did over the underdrawing. Unlike the original sketch, the underdrawing has no shading. Although I have outlined the areas to be shaded, I have left them blank, to be filled in later with paint.

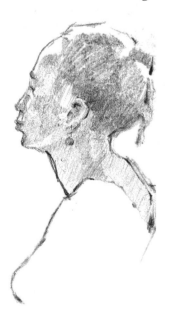
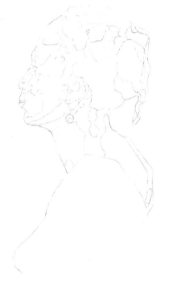
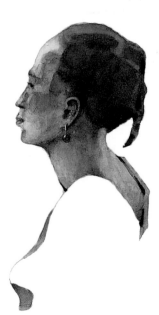

Keeping Things in Proportion

The proper proportions and placement of human features have been a challenge for artists since ancient times. This may be a difficulty for you as well—and perhaps even the most likely cause of your fear of failure. Well, here are some encouraging words: There are some useful drawing aids that can help you keep it all together.

This is a good time to introduce you to the grid system. A grid is a set of equally spaced parallel horizontal lines and a perpendicular set of equally spaced parallel vertical lines that intersect each other to construct a pattern of uniform little squares. When superimposed on an image such as a photograph or drawing, a grid divides the image into smaller units. These bite-size sections, when taken one at a time, enable you to draw the overall image in more accurate proportions. This is particularly important for you as a beginner, because one of your greatest fears is that you won't get the proportions right. But with a grid system, you can be at ease about it because you will do just fine.

There are, of course, other more elaborate devices available for drawing and painting from photographs—most of which (such as the artist's opaque projector) involve some kind of tracing process. You can use any of these other mechanisms if you like, but I urge you to avoid them for now. The use of a grid, unlike the mechanical tracing aids, requires you to rely more upon your own judgment. And the development of your own visual discernment will eventually enable you to draw and paint accurately from life. Thus a grid system, although somewhat of a bother to use, can be well worth the extra time and effort. It may do much to help you get more accurate paintings.

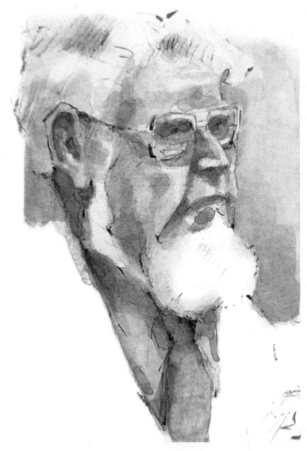

Impromptu Sketch

This is an impromptu sketch of a man whose white hair and beard caught my eye. (As is usual with my field sketches, he did not know that I was sketching him.) Rather than try to paint the man's hair with white paint, I let the white of the paper serve as the highest tonal value of his hair. I did this by lowering the tonal values around his head. I also avoided belaboring the glasses, keeping them very simple.

The Importance of Scale

In the following chapters, you will see sequential reproductions of artwork in progress. Sometimes I will show them to you at sizes that are smaller than the original works of art. Such changes in scale are more important than most people realize. The three reproductions of a single watercolor sketch at right show what I mean. The one on the upper left (A) is shown at the actual size of the original sketch. The one to the right of it (C) is shown at a significant *increase* in scale, whereas the third one (B) is reproduced at a major *reduction* from the original size. As you compare these three reproductions, notice that more seems to have changed than just the size. Reducing the painting's scale refines its appearance, polishing off the rough edges somewhat and making its details look more minute and refined. Enlarging it, on the other hand, emphasizes the rugged edges and thus makes the painting look coarser in style. You can see how the larger proportions give the artist more room to work—and to develop details that will look more refined when reproduced at a smaller scale.

This is a precept well known to professional illustrators, who typically do their artwork considerably larger than you see it in print. They even use a special tool, called a *reduction glass*, through which they periodically view a work in progress to see how it will look at its smaller reproduction size. There is nothing unethical about this. The important thing is that you be aware of this phenomenon as you compare your own work with that of a professional in a book or magazine.

Scale relationships are particularly significant when doing artwork from photographs. In this book you will learn how to work from enlargements of photographs, rather than directly from the original prints themselves. There are three reasons for this. For one, the larger size will be much more convenient to work with, as you must repeatedly look back and forth between the photo and your drawing of it. Second, the enlargement will work better if you want to use a grid system. This is, in part, because grid lines across a small photo can obscure too much of the detail beneath them. It is also more difficult to draw relatively neat, evenly spaced lines in such a small working area.

The third reason for using enlarged images is *proportional comparability*. This term refers to the comparative sizes of the photo image on the one hand, and your drawing (or painting) of that image on the other. According to this precept, it is easier to correlate the proportions of two images that are close to each other in scale than it is to bridge two images that are too different in size. Beginners often make the mistake of trying to do too large a painting from a small photo. Thus I have made things as easy for you as possible in this book by keeping each demonstration painting to the same size as the photographic image that you will be working from.

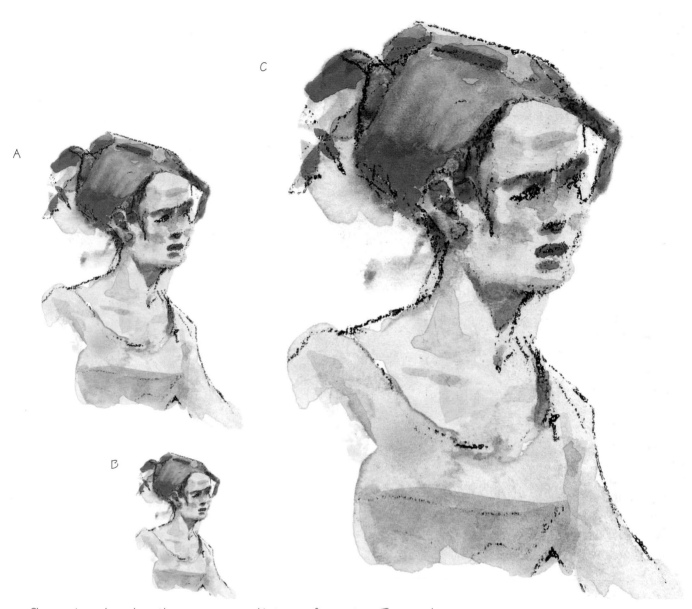

A

B

C

Changes in scale such as these are expressed in terms of *percentage*. They are also measured in terms of a single direction (the length of a diagonal line running from a lower corner to an upper corner, which is called the *aspect ratio*) rather than total area. The first reproduction (A), for instance, being the same size as the original, is shown at *100 percent*. The smaller reproduction (B) is half as high as the original drawing and is therefore a *50 percent* reduction. The largest reproduction (C) is twice as high as the original, making it a *200 percent* enlargement. Notice, though, what happens to the image in terms of *total area*. For all practical purposes, the 200 percent enlargement is *four* times the size of the original and *sixteen* times the size of the smallest reproduction.

Underdrawing One: Simple Figure, No Background

For the first demonstration, beginning on page 74, you will use a photograph that I took of a friend on a dim, rainy afternoon. I am showing the image to you here at the actual size that it appears on my photographic print. To simplify things for you, I will leave the background out of the painting. I will also show you how to use a grid system.

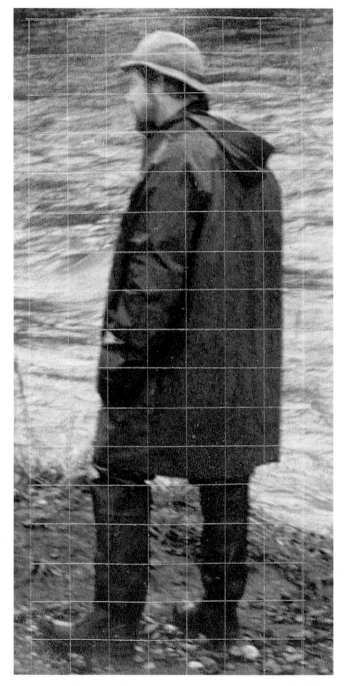

Step 1
This is the photograph of my friend on a fishing trip on an overcast, rainy day.

Step 2
This is a laser-photocopy enlargement of the figure at 300 percent of the original dimensions. I have superimposed an 8½-inch (22cm) high grid system that is divided into ½-inch (1cm) squares on the enlargement. I have drawn the grid system in white rather than graphite to show up better against the darker parts of the figure. Now the photographic image can be transferred to your watercolor board.

Step 3

Draw a grid system on your watercolor paper or board that corresponds to the one on the enlargement. (This is a *reciprocal grid*.) Here I have made the reciprocal grid the same size as the one on the photocopy. Reciprocals do not have to be the same size as the initial grid system, however. For example, you can use a bigger reciprocal to enlarge an image or a smaller reciprocal to reduce an image. But the grid must have the same number of squares in each direction as the initial grid. Now you can transfer the image by drawing lines that represent the edges of the forms in the photo. Work your way through the system one square at a time. I have begun with the contours of the fisherman's hat.

Underdrawing Two: Figure with Some Background

This underdrawing is for the demonstration beginning on page 78. Cowboys and cowgirls are my favorite people to paint because I like their style and the way they look. The most convenient way I have discovered to find cowboys and cowgirls is to go to rodeos with my sketchbook and camera. One summer day, while I was behind the chutes at a rodeo in Utah, I saw a contestant limbering himself up for his ride. Realizing that I had an interesting "pose" here, I quickly took a snapshot of him. Although, as in the previous demonstration, this is a single figure, the anatomy and shading are more complex. I will also bring in part of the background this time, using cast shadows to suggest a sense of depth. And in doing so I will show you how to use your artistic discretion. You will see how I determine which of the background elements should be included and which should be left out. And I will show you how to adjust those background elements to make them more suitable to the composition.

Taking Your Own Photographs

When working from your own reference photographs, be certain that each image you use has strong eye-catching appeal. This will render your best artwork. If, on the other hand, the photo's imagery is weak and dull to behold, the artwork you do from it will probably be just as bland.

Here is a hint that can help you take good reference photos of people when you are out in the field. Whenever possible, take multiple shots. There are occasions, of course, when you cannot do this. Situations can be too transitory, giving you very little time to react. You may have barely enough time get one click—or two at the most—before time runs out. There will be times, however, when you have enough time to take extra shots. If so, I urge you to do it. It is unlikely that any two shots will look exactly alike. And you might have to take several of them to get at least one good shot that you can use. This is a postulate well known to professional photographers. And it is a principle that applies just as much to collecting reference photos for your art. So take your camera and plenty of film with you wherever you go.

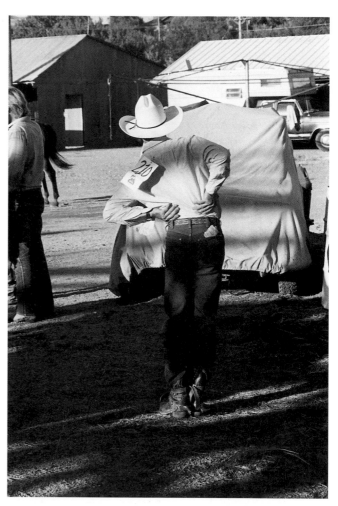

Step 1

This is a photograph of a rodeo contestant as he stretched for his ride. I snapped this shot because his posture looked unusual and interesting to me.

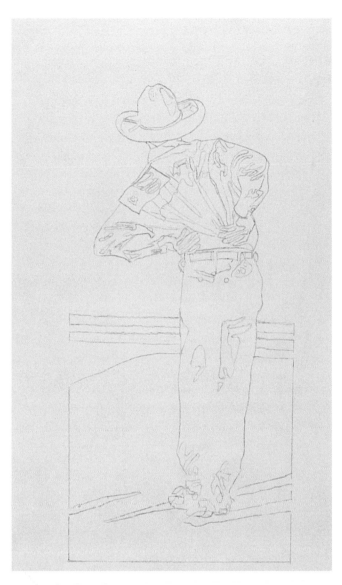

Step 2

In the underdrawing, I must include some of the cast shadows on the ground as a visual context for the figure. This explains the darker areas across the cowboy's back and legs. Otherwise, the finished painting would bewilder someone who may wonder why the cowboy is wearing clothing dark in some places and lighter in others. Remember that in representational art, we are working with illusionism. If the illusion isn't just right, it won't work. Fortunately, the solution to this problem is quite simple.

I have included the cast shadows but have simplified and rearranged them. The shadows of the people in the left of the photo aren't necessary. I also have eliminated the covered automobile in the background. In its place I extended the two distant, narrow shadows that fall across the picture. I have cropped out much of the extraneous area around the figure, thereby improving the composition and focusing on the cowboy himself.

Just as with the fisherman, I have given you a base drawing that includes the outlines of the tonal shapes on the cowboy's clothing. This time, though, the stretched-out and crinkled shirt produces much more complex tonal shapes, resulting in a more intricate pattern of lines. Even though I have simplified the details in the shirt, it still may look discouragingly complicated. But I can assure you this will be the easiest way to learn to paint realistic clothing.

Working from Your Own Photos

When you reach the point at which you are ready to do your paintings from your own photographs, I recommend a camera that uses 35mm film. Have your photo shop make your prints at "full frame" on 4-inch × 6-inch (10cm × 15cm) paper. The shorter 4-inch × 5-inch (10 cm × 13cm) paper requires the lab to crop each end of the print one-half inch. Those areas may well contain imagery important to your painting.

Whenever you want to do a painting from a print, there are three ways to enlarge it. You can have your photo shop make a larger print. This will give you the clearest image by far.. It is, however, the most expensive and bothersome way. You also can enlarge it with a laser-photocopier (I would not advise you to use a regular photocopy machine for this process because the reproduction quality would be poor.). Or, you can enlarge it on your computer if you have the right software.

Underdrawing Three: Multiple Figures in a Simple Scene

For the demonstration beginning on page 82, I am increasing your challenge by giving you multiple figures to work with. Yet I'll make it easier for you by omitting most of the visual clutter that surrounds the figures, leaving just the cast shadows to create a sense of spatial placement. I will also show you how to simplify and "economize" your imagery by leaving out unnecessary minor details.

You will be working from parts of two photographs that I took one summer afternoon in a dirt parking lot. The shots include a group of three men who were engaged in a conversation. A few feet away from them was a fourth man who had been walking through the lot but had paused for a moment. I took these two shots while I had the chance. Upon reviewing the prints later, I decided that I liked the group of three men best in one of the

two shots, but I liked the fourth figure better in the other photo. This problem was easy to resolve. I merely cut out the part of each of the photographs that I liked and taped the two pieces together. A slight adjustment in the shadow of the fourth man—to realign it—and the two component parts fit together just fine. And sure enough, the four figures and their long cast shadows all work together to make a pleasing composition. But just for fun, my wife asked me to let her experiment with the images on her computer. After scanning them into the system, she distorted the figures by elongating them vertically. The experiment was a great success, resulting in a very fascinating effect. She did the figures in varying degrees of elongation and let me pick out the one I liked best. You will be doing the base drawing from that computer printout.

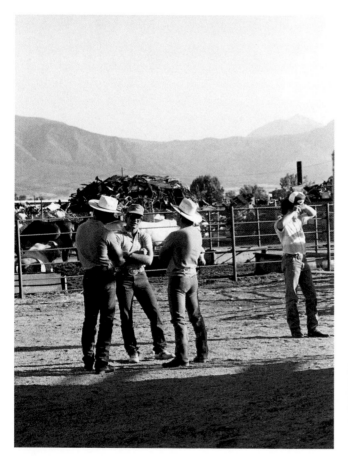

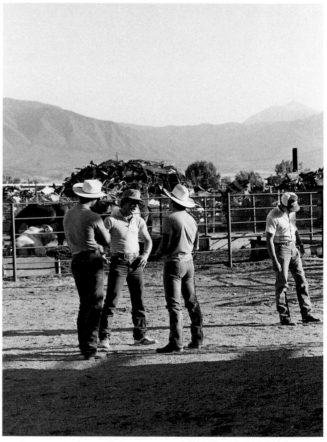

Step 1
 I like the shot of the group of three men standing in an old dirt parking lot in this photo.

But I like the shot of the lone fourth man in this photo. I had the photo shop make larger prints and crop out the extra space around the figures.

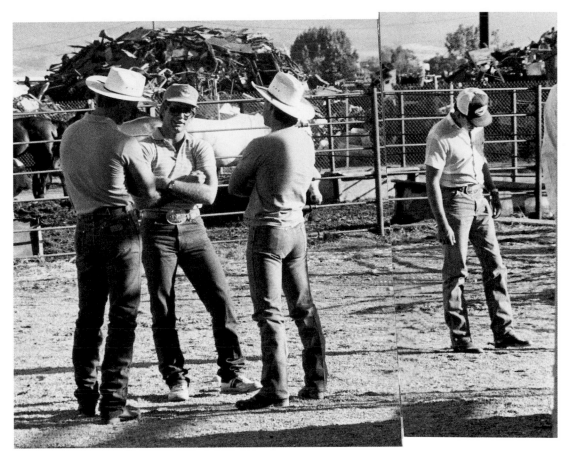

Step 2
I cut each picture and taped together the two parts that I wanted. The resulting composite photo is shown at actual size.

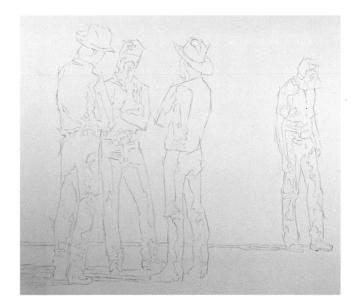

Step 3
Here is the underdrawing with the elongated figures. I have drawn only the four men and their cast shadows. These elements are really all I need to include. The shadows will help give the composition a sense of unity. In addition they will create the illusion that the figures are occupying an three-dimensional space. I have taken care not to draw too many of the details on the figures, but instead have included only the major forms. Deciding which details to keep and which to eliminate is a judgment call. If I were to do this drawing again, I might not do it exactly the same way.

Underdrawing Four: Relating a Figure to Its Surroundings

For the demonstration beginning on page 84, I will show you how to relate a figure to its background and other surrounding elements. I will also show you how to take elements from two different photos and arrange them so as to combine them into one composition.

You will be working from two photographs. The first is a snapshot that I took of my young son on a pier as he was looking at some nearby pigeons. Unfortunately, the timid birds would not come close enough to him for me to include them in the same shot. My solution to this problem, though, was quite simple: I waited until my son had walked out of the scene and the pigeons had walked into it. A separate photo of them gave me all the parts I needed to put together a good, interesting composition.

Whenever you paint a figure in a scene, you will want that figure to look like it belongs in the same picture with all the other elements of the setting. This is the principle of *unity*. There are three ways to achieve unity.

One of them is consistent lighting. Light correlation has two aspects. The first is consistency in the *quality* of light. In other words, a figure in a painting must be illuminated in the same way as the other figures or objects around it, or they won't look right together. Imagine, for example, a figure that is brightly illuminated by a direct single beam of light standing right next to another figure that is illuminated by softly diffused light. Unless there is something in the depiction to explain the difference (such as having the softly lit figure standing in a shadow), they would not look like they belong in the same painting. The *direction* of illumination also must be consistent. If two figures or objects are next to each other, they must be lighted from the same source. If one of them has its shadow side on the right, for instance, it would bewilder the observer to see it next to another figure or object with the shadow side on the left. Likewise, all of the cast shadows must fall in the same direction.

Actually, you already have applied the axiom of lighting consistency in the depiction of the four men. In this painting you will use it again, this time in combination with the other two principles of unity. One of these is *chromatic harmony*. This simply means that the colors of your figure must correlate with the general color scheme of the painting. This color scheme defines the overall chromatic atmosphere, which tells you such things as what the color of the shadows should be.

The remaining way to achieve unity is to relate your figure to its surroundings by creating the illusion of a comfortable three-dimensional space around it. You want your figure to look like it occupies its proper position within that illusionary space. This is the principle of *perspective*. Perspective comes in two forms—*linear perspective* and *atmospheric perspective*. In this chapter we will establish the linear perspective for the painting. We will deal with atmospheric perspective when we do the actual painting in chapter 5 (beginning on page 84).

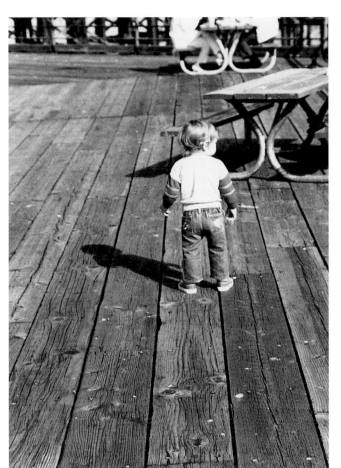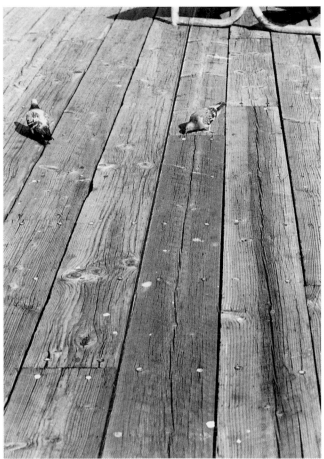

Step 1

These are the original photographs of my son and the two pigeons on the pier.

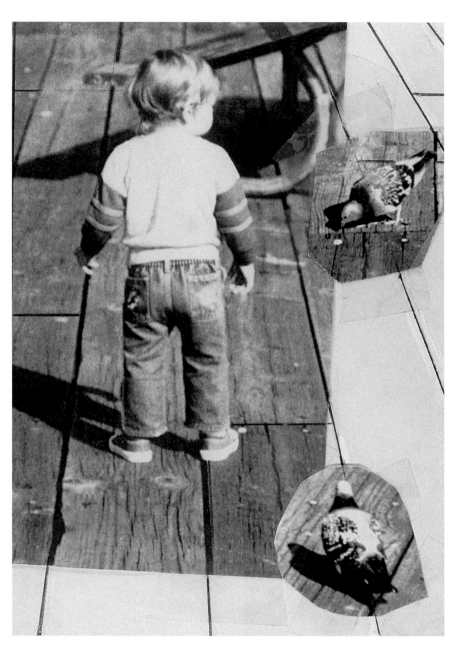

Step 2

I had the figure laser-copied at 300 percent. I had the two pigeons enlarged as well, each at different sizes. I had the closest one enlarged the most and the other enlarged the least. I wanted to make sure they each fit the composition's system of perspective. When I decided which laser-copy of each bird was the right size, I cut them out and taped them onto the photo of my son. I have taken care that the cast shadows all fall in the same direction. This consistency will give the base drawing and the final painting a sense of overall unity. I then drew a rectangular boundary around the three images to establish the overall composition.

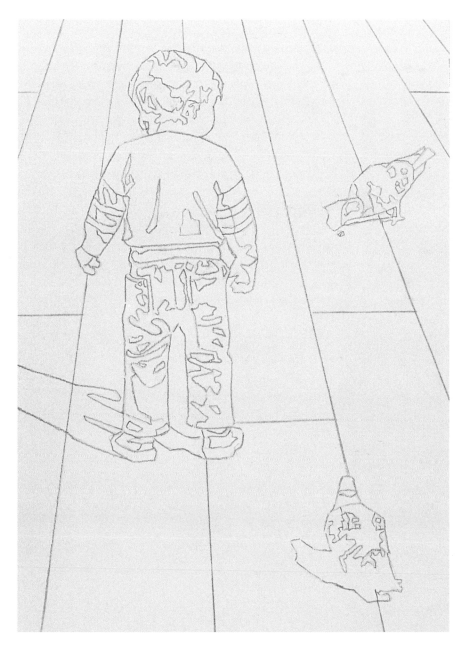

Step 3

In the underdrawing, I have eliminated the picnic table in the background, and filled in the rest of the lines between the wooden planks. These will conveniently serve as the orthogonal lines (the lines that go off into the distance) that offer a simple one-point perspective system. I have added some new lines on the right side of the composition with a simple procedure. First I extended the existing lines off of the top of the picture until they met at their vanishing point. From there I was able to measure off the new lines. I added one detail to the composition—a speck of food for the pigeon in the upper right.

Underdrawing Five: Two Figures in More Complex Poses

For the demonstration beginning on page 88, I am introducing you to some new considerations. You will, for the first time, be working from a drawing (actually two drawings) instead of a photograph. I will show you how to convert a preexisting sketch on regular drawing paper into a watercolorable form. You will also be dealing with more complex postures, with seated figures and foreshortened limbs.

This painting will also give you an introduction to a more spontaneous approach to painting people and portraits. In this sense, the demo painting will show you how to take your first few steps on the wild side—to experience the exhilaration of impromptu watercolor sketching. But it will explain how to do so in a way that minimizes your fear of failure. You will learn how to get started in candid sketching without entirely leaving the secure comfort zone of a preplanned and cautious watercolor procedure.

Your subjects this time are two swimmers that I drew several years ago on two different pages of my pocket-size sketchbook. When I do these mini-sketches, my subjects rarely know that I am drawing them. I have learned how to be nonchalant and inconspicuous enough that I seldom get caught at it. The man's head was facing directly toward me all along, but because of his sunglasses I couldn't tell for sure whether or not he was looking at me. Since he never moved for the entire time (the sketch took me less than two minutes to do), I think that he may have been dozing. Either way, the direct frontal view of his face worked to my advantage when I merged the two sketches into a single composition.

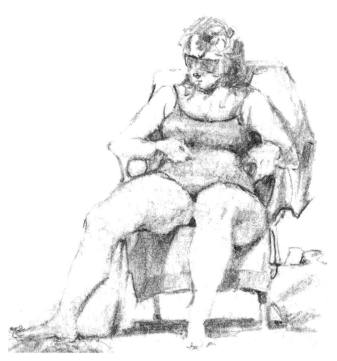
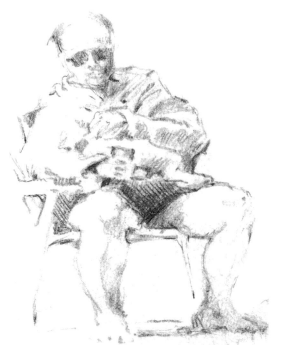

Step 1
These are sketches of two swimmers one sunny summer afternoon. The sketches are shown here at their actual sizes. To convert them to watercolorable form, treat them just as you would a photograph.

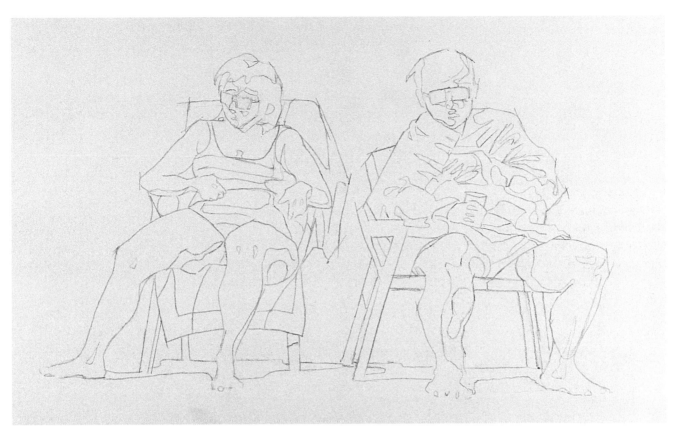

Step 2
On my watercolor board, I have combined the two
sketches into a single composition, filling in some
details, such as the legs of the man's chair. I didn't
worry about ambiguities in some of the details,
particularly in the man's big towel. This is, after all,
an impromptu sketch.

Transferring an Image from Drawing Paper to Watercolor Paper

Sometimes I convert preexisting sketchbook drawings by simply photocopying them onto Aquabee 808 paper. This works especially well with small sketches that don't have much graphite shading. This process changes the appearance of the sketch, but it still works rather well.

Above is a quick sketch (shown at actual size) that I did of a student as she was busily working on a drawing assignment in my class. Because I had used very little shading with my pencil, this sketch is easily convertible to watercolorable form.

This is a photocopy of the sketch shown above, done at the same size as the original. You can see that the copy differs from the original in appearance, mostly in its line quality. The lines are now starkly black, with much more contrast against the white paper. Yet the drawing still looks good. The dark lines, although more prominent now, actually go very well with the watercolors that I will add.

Sketching in the Field

Sketching people out in the field is a very different experience from drawing and painting them from a photograph or in a studio setting—particularly when they do not know you are sketching them. They aren't posing for you. You have no control over the lighting conditions. You rarely have control over the distance or vantage point from which you see them. They frequently leave the scene before you have finished your sketch. All of this requires a completely dissimilar frame of mind and a different set of expectations from the artist. You must learn to make do with what you have. You must accept the fact that you may not always finish a sketch before your subject stands up and walks away, so you must decide whether to leave it unfinished or to finish it from memory. You must sometimes do the entire sketch from memory. But all of this is what makes sketching people so much fun.

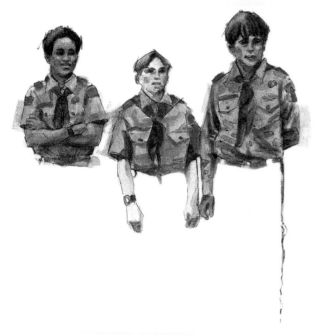

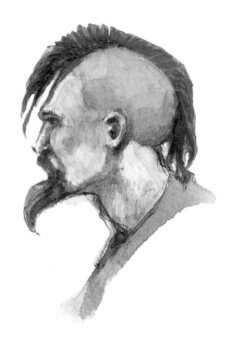

I had a very limited amount of time to do this watercolor sketch, and it would have taken me twice as long to draw the entire bodies. So I quickly roughed out the most important part of each of them with a ballpoint pen (I had forgotten my pencils) and added the watercolor later. To avoid an awkward "floating" look, I continued one of the boy's left contour lines almost down to the floor. This confirms to the observer that the boys do indeed have complete bodies— without my having to fill in all three of them all the way down to their shoes.

The world is full of fascinating people. This is a young man that I spotted one day while waiting for a trolley. I was unable to sketch him at the moment, but once seated on the trolley I was able to get out my pencil and watercolor pad. While his image was still fresh in my mind, I sketched him from memory. As soon as I could after that, I got out my field box and finished the sketch with watercolors.

CAPTURE A LIKENESS

In this chapter I will introduce the models whose portraits you will paint in chapter 6. Along with the photograph of each model, I will show you the underdrawing from which you will paint the portrait. This will enable you to compare the photo to the drawing so that you can see how I translated the photographic image into the underdrawing.

You will find that doing an underdrawing for a watercolor portrait is no different from doing one for a figure painting. You chart out the shapes—including the tonal shapes—that you see before you in your model. And as with the figure paintings, you will use the underdrawings as maps that will tell you where to put your paint and how much of it to put there.

Tami
9" × 7½" (23 cm × 19cm)

Likeness and Lifelikeness

Getting a likeness simply means that your painting looks just like the person that you are portraying. There is no special secret to getting a good likeness. It is just a matter of doing a careful underdrawing, because a person's likeness is defined by the shapes that together constitute a face. If you can accurately chart those shapes, you will get a good likeness. In this chapter, I will show you how to do this—and do it with full confidence that you will succeed. Although a good likeness will help you get a satisfactory lifelikeness, there is more to it than that. There are rules that you must obey if you want to get a credible lifelikeness.

The first of these rules is the proper proportion and placement of features. Every visual feature of your model must be the right size and in the right place. This is of specific importance, of course, in your subject's face, where it helps to define the likeness. But is also important in the greater anatomy of the subject's body. The arrangement and size relationship of the subject's head and shoulders, for instance, must be correct. An arm must appear to bend in the right place; otherwise, the model's anatomy will look awkward and unnatural.

Lifelikeness also requires natural-looking colors, particularly in the flesh tones. Your choice of hues for the skin must look right within the given color scheme of your painting. Pasty or bizarrely colored skin will make your painting most unpleasant to look at.

The proper contrast in tonal values is just as important as the choice of colors. One of the telltale signs of an amateur portraitist is a flat, volumeless appearance of faces and figures. If you want your portraits to be lifelike, they must have a three-dimensional quality. Representational art is, after all, the art of illusion. You must know how to paint a nose so that it seems to really project out from the person's face. Eyeballs have to look like they are set back into their sockets, and they must be genuinely round—even though you can see only a small part of them. This is, by the way, why I recommend against painting portraits from photos taken with flash cameras. The flash usually washes out the face with a flood of frontal light. This may work in the photo itself, but as a painting it will look disturbingly flat.

I admit that each of these rules may be broken. It is even possible to break all three at the same time and get away with it. But my many years of experience have taught me that the only artists who can successfully rebel against these principles are those who have already achieved a thorough mastery of their craft. I advise you to abide by these rules.

In this chapter, we will deal with the first of the three precepts: the placement and proportion of features. The other two—color and tonal contrasts—will come back up in chapter 6.

At this point, you are ready to meet your portrait models. I will introduce them to you in the order that you will paint them in chapter 6.

Using Proportional Dividers

Using the grid system to do portrait underdrawings will help you get accurate proportions and placements of facial features. However, if you wish to wean yourself from grid systems, you may want to make use of a pair of proportional dividers (see page 17) when working from photos or from life. Like the grid system, you can use this tool to enlarge or reduce an image. You can determine the degree of enlargement or reduction with the settings on the two crisscrossing dividers. For example, you can set the dividers at a 2:1 ratio to reduce an image by one-half (see explanation below).

You can also tighten up the accuracy of your underdrawings with vertical and horizontal alignments. For instance, you have finished a subject's eyes and nose satisfactorily. You must decide how wide to draw the mouth. To place the corner of the mouth, find the part of the eye directly above it by holding a pencil vertically in your line of sight while looking at that part of your model. Place and proportion each ear by finding what part of the face is directly across from the part of the ear you are drawing. Do this by holding your pencil horizontally in your line of sight as you look at that part of your model. Determine how far out to place the ear with your proportional divider.

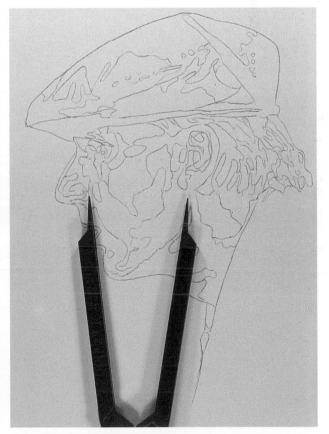

You can use proportional dividers to take comparative measurements between your photo and your underdrawing to ensure proportion and placement accuracy. For example, to reduce an image by one-half, set the dividers to a 2:1 ratio. Take a measurement from your reference photo with the wider side of the dividers, then turn the dividers to the narrow side to draw a proportionately accurate but reduced line or area on your underdrawing. To enlarge an image, use the smaller end on the reference and the larger end on the underdrawing.

Portrait Underdrawing One: Elaine

Your first model, for the demonstration beginning on page 96, will be my daughter's college friend, Elaine Miyazaki. To simplify this first project, I will limit the scope of this practice portrait. You will be painting only Elaine's face, omitting her hair and neck.

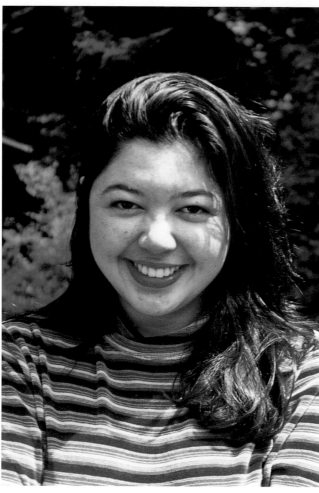

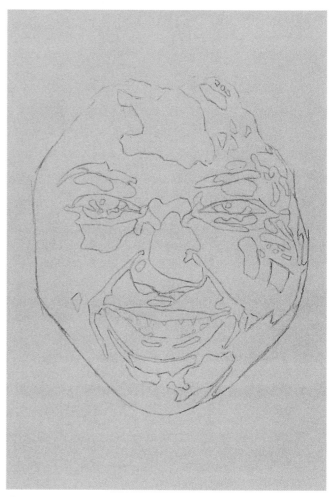

There are two things in particular that I want you to observe here. One of them is the catchlights in Elaine's eyes, which are on the opposite side of the source of light. Usually they are on the same side as the light source, which is in this case the sun. Her eyes are in the shade of her eyebrows. Yet the sunlight is bouncing off a nearby surface (the front of my house) and back into the shadow side of her face. This is what has caused the unusual positions of the catchlights. To deal with this, you have three choices. You can either leave them where they are, move them over to the other side or eliminate them. This is strictly a judgment call. In my demonstration version of Elaine's portrait, I have chosen to leave them as they are. That's what I suggest you do, too.

Note how I have rendered Elaine's beautiful smile. I have softened the definition of the teeth by omitting all the contour lines of each individual tooth. This is likewise a judgment call. Many portraitists would have rendered the lines between the teeth, but I think it looks better this way. I think it is best for you to do so as well to avoid the danger of overdefining the teeth, which can ruin an otherwise great portrait.

A Closer Look at the Eye

In this chapter and chapter 6, I talk about *catchlights*. A catchlight (sometimes called a *highlight*) is a tiny beam of light that ricochets off the smooth and moist surface of the eye. This usually produces the visual effect of a white (or nearly white) spot appearing somewhere on the eyeball. Catchlights can vary in three ways. They can occur anywhere on the eyeball, including the "white" of the eye, depending on the direction of the original light source. The ideal location for a highlight is where it straddles the pupil and the iris—at about the 10 o'clock or 2 o'clock position. When the source of illumination is directly in front of a face—as when using the flash on a camera—the catchlights can be right in the middle of the pupils. This is the worst possible place for them to be—unless you are trying to create an eerie effect. When you are doing a painting from a photograph in which the catchlights are centered in the pupil, exercise your artistic license and move them to one side or the other. Move them to the side that appears to have the most light on it. If both sides of the face are illuminated equally, they can go either way.

Highlights can vary in size and intensity according to the quality of the light source. and in number according to the number of light sources. (Usually there will be just one catchlight; and sometimes two.) Sometimes when an eye is in the shadows, there may be no catchlight at all. Sometimes, you can add highlights to eyes that are in the shadows to give them a little extra spark of life. But if you add them to eyes that are too deep into the shadows, you will get a very unnatural and bizarre result.

In a pair of eyes, the catchlights may not always match—although in fully frontal poses they usually do. There may even be a catchlight in one eye but not in the other one. How, when and where they do or do not occur, catchlights can be essential to getting a good lifelikeness.

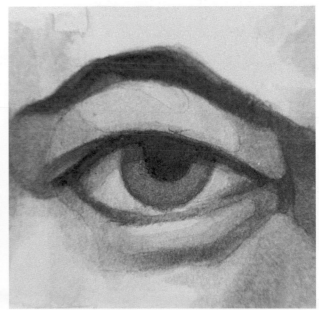

These two versions of the same eye demonstrate the importance of catchlights. Not only does the one on the right look lackluster and somber, but also dreary—and even sinister. As you study this eye, observe how I rendered the eyebrows and eyelashes. Notice that I did not try to paint the individual hairs. I instead treated each group of hairs as a solid tonal shape. If you try to get more minute in your details of any kind of hair, you will probably just frustrate yourself. Simplifying hair like this will save you much grief.

Portrait Underdrawing Two: Robert

Your model for the second portrait demonstration, beginning on page 100, is Robert Treat. Robert is one of my favorite portrait models and has posed for my portrait classes several times. His distinct angular features make him an excellent choice for a profile view. In this portrait you will expand the scope to the entire head—including the cap and hair.

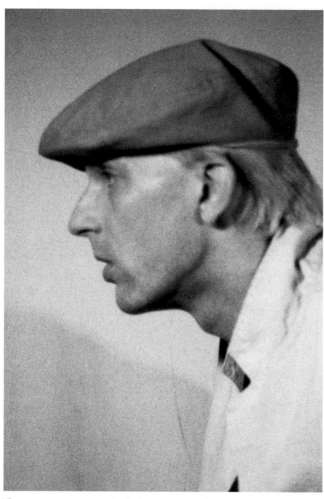

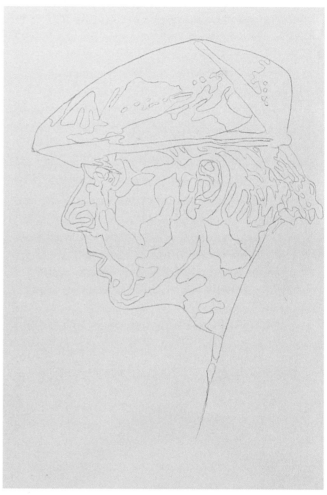

There are two anatomical observations that I want you to make in Robert's facial profile. First, note that the lower eyelid is set back further into the head than is the upper eyelid. In this pose, of course, this effect is exaggerated by the forward incline of Robert's head. But even if you tilt the page clockwise to straighten the head upright, the lower eyelid is still tucked further back into the head than the upper one.

You also can see that the nostril has a definite shape. The edges of the nostril are hard on the top and front, but softer on the bottom and rear sides. Note that the dark shape of the nostril phases right into the undershadow of the ala (the "wing" of the nose) behind it, which curls up in the alar furrow behind the nose.

Portrait Underdrawing Three: Whitney

Your next model, for the demonstration beginning on page 102, is my niece, Whitney Bennett. I took this photograph of Whitney from a family video. I set my camera and tripod up in front of my television screen. My daughter operated the pause button on the VCR for me while I worked the shutter release on the camera. This is an excellent way to get refer-ence photos for your watercolor portraits. I took several shots of her this way. When I got the prints back, I selected the one that best exemplifies her radiant smile. In this shot, there are very pro-nounced catchlights in her eyes that accent the enchanting gleam of Whitney's personality.

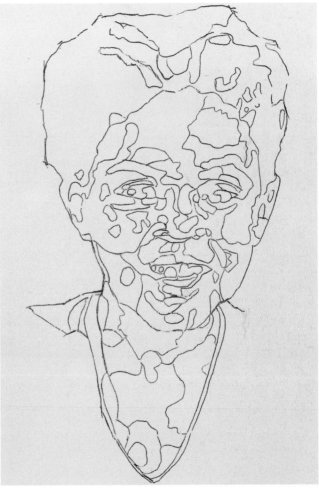

In the underdrawing I have filled out the top of Whitney's hair using some of the other reference photos that I took of her. Observe how I have delineated only the major tonal shapes in her hair. It would be futile and frustrating to try to render every strand of her hair. To avoid the "floating head" effect, I have included a suggestion of Whitney's shoulders.

Portrait Underdrawing Four: Tami

Your fourth model, for the demonstration beginning on page 104, is Tami Holson. The reference is a drawing of her that I did to illustrate a "Drawing Board" column for *The Artist's Magazine*. I have since decided to do a larger, painted version of this portrait. The painting that I will demonstrate with Tami will be an intermediate phase—a flesh-tone study for the final portrait. In doing so, I will show you how to paint a portrait from a drawing rather than a photograph.

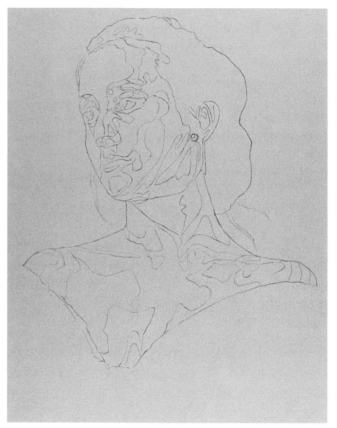

For a flesh-tone study such as this, it is unnecessary to paint the entire image that appears in the drawing—with the robe and right-hand fingers. It will, instead, be essentially a bust, *which is also known as a* head-and-shoulders *portrait. This, therefore, will be an anatomical extension from the portraits that you have done so far.*

Portrait Underdrawing Five: Lauren

The model for your fifth portrait demonstration, beginning on page 106, is Lauren Folk. Up to now you have been gradually expanding the scope of your portraits—including more and more of your subject's anatomy. For this painting you will zoom in even closer than you were with the first portrait. This will focus your attention on the subtlest qualities of complexion. I will show you how to paint Lauren's delightful freckles, and I will teach you how to portray the ever so slight—yet vital—shifts in the hues on the surface of her skin.

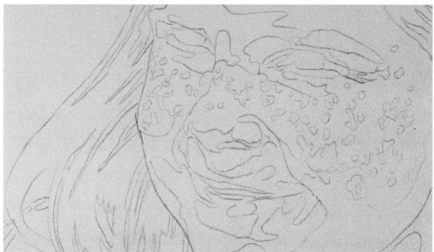

In this underdrawing, I again focus your attention on the model's face. This time I will do it differently than I did for the first two portraits; I will isolate and contain the area of concentration by drawing a boundary line around it. This area will encompass some of Lauren's hair and will include a small part of the background behind her. With this I can show you how to relate her flesh tones to the background colors.

Portrait Underdrawing Six: Chuck

For the portrait demonstration beginning on page 112, you will work from a photo that I took of a long-time friend, Charles Fuchser. Chuck is another of my favorite subjects. I have done more pencil and watercolor sketches of him than any other person. You can see why. He has a most impressive appearance. With Chuck I will show you how to paint facial hair. I will also show you how to work with a slightly fuzzy photo. I took this picture of him with a new camera that I was trying out. Because the light in the room was so low, my camera automatically chose a slower shutter speed. (I had turned the automatic flash off.) Because I couldn't hold the camera still enough for the slow shutter, I got an image with slightly blurred edges. It isn't so fuzzy, though, that you can't paint a portrait from it.

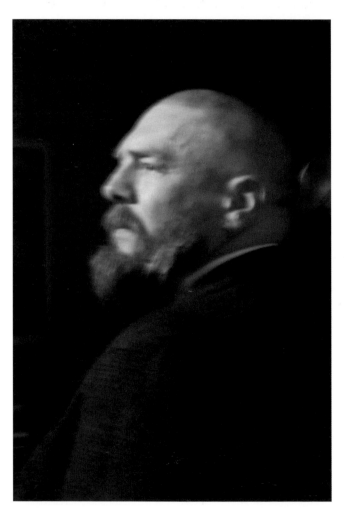

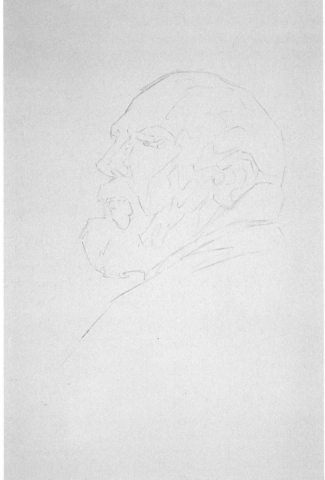

In the underdrawing, I have limited Chuck's portrait to his head and coat collar. The contours in the photo were fortunately not so blurry that I could not draw them. This solution to a hazy-border problem, by the way, would not work if the edges were much more blurry than this.

Portrait Underdrawing Seven: Liz

Your model for the portrait demonstration beginning on page 116 is my niece, Elizabeth Ogilvie. You will be will be working from a black-and-white photo that I took of her many years ago. (She is almost grown up now—but still just as cute as she was then.) It was a sunny but cold day, and Liz was sitting on the sidewalk steps in front of my home in a warm and fuzzy coat. In your portrait of her you will learn how to paint a face that is partly in bright,

direct sunlight and partly in shadow. An image like this is ideal for a watercolor portrait. The sweeping sunlight and cast shadows provide excellent tonal shapes to work with. I will show you how to use those lights and shadows to create a delightful chromatic effect with the shifting hues in the shaded areas of her complexion. I will teach you show to paint her hair and I will show you how to capture the textural effect of her big fuzzy collar.

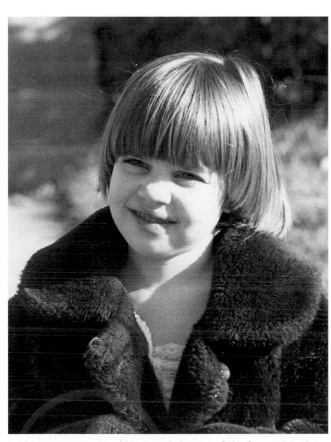

In this picture, most of the tonal shapes of the face are in the shadows. Do not overlook these.

I have blocked out the major shapes in Liz's hair. You must be economical here. You can't draw all the tonal shapes within her head of hair—there are too many of them. And you certainly cannot draw every individual strand of hair. So I have just outlined those shapes within the hair that are the most pronounced—the ones that are larger and darker. These will help to break up the body of hair visually and indicate the direction of the hair's downward flow.

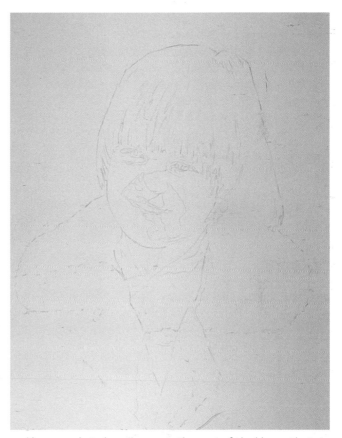

I have used similar economy in the part of the blouse that you see in the V-neck of Liz's coat. Again, I didn't try to draw every tiny detail—just denote the major ones. You will paint these tonal shapes with a flesh tone to give the appearance of her skin color showing through.

In the collar I have used softer contour lines that are less distinct. This will better accommodate the fluffy textural effect that you will create in chapter 6.

Portrait Underdrawing Eight: Ben

Your last model, for the demonstration beginning on page 120, is Ben Sanford. I have done numerous demonstration life drawings of Ben in my studio. Your portrait of him will include his upper torso and his hands. He has on a shirt that I like him to wear when I'm teaching students how to draw clothing. It is a simple, completely white shirt with clearly discernible folds—but few other cluttering details. This makes it ideal for a portrait. I recommend that, when you begin to do portraits with your own models, you have them wear similarly unadorned and simple clothing. A plain white or light-colored T-shirt (one that doesn't have any graphics on it), for instance, would work just fine. Later, after you have had more experience, you can challenge yourself with more visually cluttered attire.

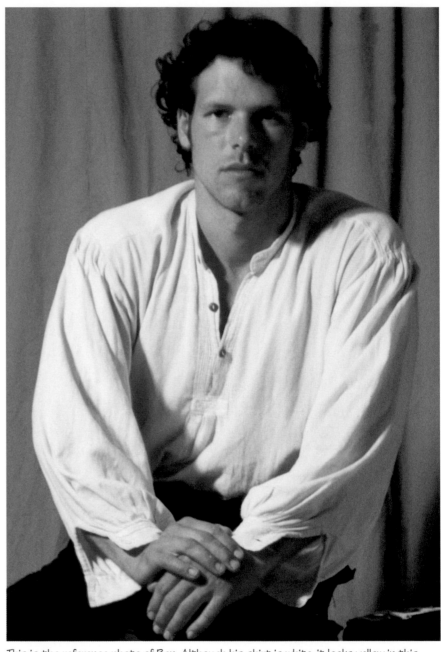

This is the reference photo of Ben. Although his shirt is white, it looks yellow in this photo. That tells us that the other colors in the shot have shifted hues also. The colors in photographs are not always reliable, so remember that you are not bound to match the colors that you see in your reference photo.

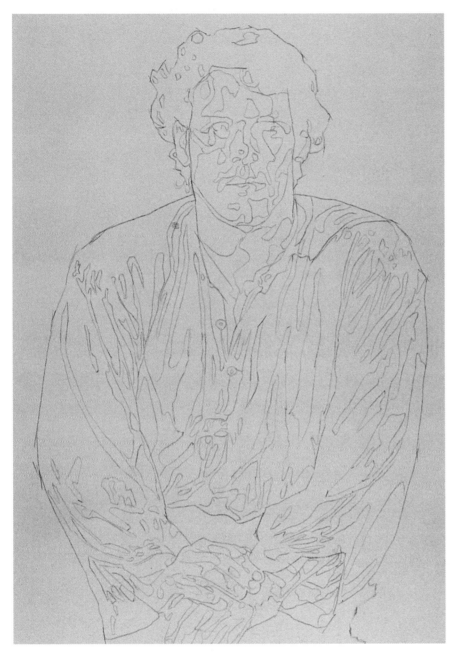

To simplify this portrait as much as possible, the underdrawing of Ben excludes all of his lower torso. I have drawn some lines below his left arm to suggest the stool upon which he is sitting. This will help to avoid a top-heavy, cutoff look. I have simplified Ben's hands by leaving out all minor details, choosing instead to delineate only the major tonal shapes. Hands are difficult to get just right—and easy to botch up. They are even harder to do than faces. As you will see, though, this approach will work just fine. It will make the hands easier for you to do—and lessen the risk of failure.

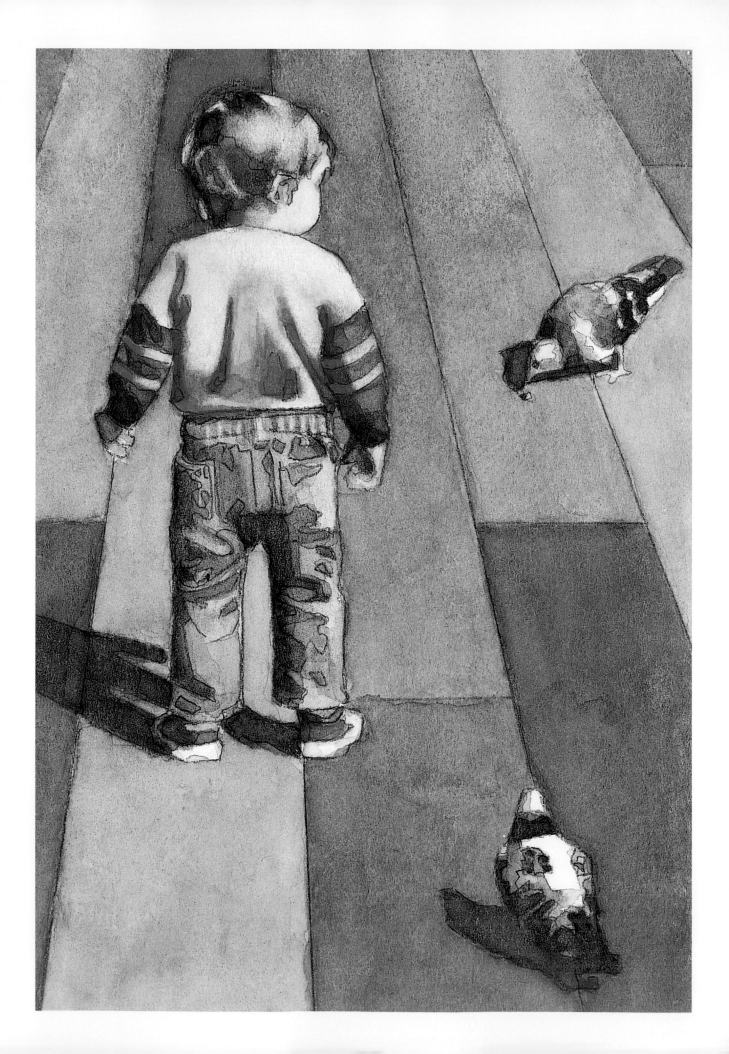

BATHE YOUR FIGURES IN LIVING COLOR

In chapter 3, I told you that every time you apply paintbrush to paper or board, you must make at least four determinations:
- *where* you will put the paint
- *how* you will put it there
- *which* color you will put there
- *how much* of it you will put there

I have already shown you how to decide *where* you will apply your paint. In chapters 3 and 4, you made underdrawings with which you literally charted the entire surface of your subject. Those under-drawings will now serve as maps that will tell you where to place your brush and deposit every drop of your watercolor paint. In this chapter I will show you how to make the remaining three decisions.

Pigeons
7½" × 5½" (19cm × 14cm)

How to Apply Watercolor Paint

You will be doing most of your painting with a method called *layering*. When using transparent or semi-transparent pigments as I have prescribed in this book, layering is also called *glazing*. You will be using solutions of diluted watercolor paint to slowly build up your tonal values by carefully glazing one layer of paint over another. This will enable you to accumulate several thin layers of paint without losing the beautiful luminosity of watercolors.

Layering

The process of learning to layer paint can be divided into three phases. For the first phase you will need vanishing-image paper and clear water to develop the feel of layering and your brush technique. Don't skip this step; if you don't have vanishing-image paper, do the following exercises on watercolor board with a thinned mixture of paint.

Full Wash There are three ways to apply a layer of paint with your brush. One is to lay in a full wash. First, load a medium-size brush with water. You want the brush to be as saturated as possible. Let the tip of the brush lightly touch the surface of the paper, causing it to release some of its water, which will flow down onto the paper. Now try moving the brush either in a circular motion or in a straight line. When your brush has discharged most of its water, recharge it and continue. With this method you can deposit a wide layer of paint with little or no friction between the brush and the paper.

Wiping This is the second way of applying a layer of paint. Charge your brush with water, just as you did before. But this time discharge the excess water from the brush before you apply it to the paper. The best way to do this is to pull your brush tip across the edge of your water container, which causes some of the water to run back into the container. Now apply the water to the paper by wiping it across the surface with the downward pressure of an actual brushstroke motion. Spread the water across the surface as you go. Try this with varying degrees of brush saturation. A more loaded brush will work almost like a full wash because the water still is floating loose on the surface. A brush that has much less water in it will deposit a thinner layer of paint.

Scumbling This is the third method of applying a layer of paint. After dipping your brush into your of water, remove most of the water by blotting it with a paper towel. Then, deposit a very thin film of paint with a gentle rubbing motion.

Scumbling is less likely to cause unintentional lifting of previously applied layers of paint than some other techniques (see page 70). Being much less wet, the paint will not soak the coat of paint beneath and will allow you to build up your tonal modeling in more subtle ways. I use it mostly toward the end of the modeling process to touch up and smooth off any small patchy areas by filling them in with paint.

LAYERING TECHNIQUES
These are examples of layering techniques using the same solution of diluted watercolor paint. On the left I applied a small but juicy wash with my Isabey no. 6 retouching round. This is the perfect brush for painting small details, but other small watercolor rounds will work, too. In the middle I used the same brush with less watercolor solution. This time I had to apply the paint by wiping it across the surface with the brush.

Building Layers

When you have developed the general feel for layering brushwork, you are ready for the second phase. For this, you will move to your experimentation sheets and use actual watercolor paint. Begin with a very diluted solution of a single color such as Cobalt Blue. Apply that solution to a small area (about 3" × 3"; 8cm × 8cm) on the paper or board and let it dry *completely*. Then add another layer of the same mixture right on top of the first and allow it to dry thoroughly as well.

Continue building up layers of paint this way until the paint has accumulated enough that you can barely see the difference when you apply each new wash. At this point, start using a less diluted wash by adding some more paint to the solution—and resume the process of layering. When you again get to the point at which you can barely see each new layer, add some more paint to your wash and resume the process. Build up the paint until it becomes somewhat dark.

For the final phase, bring in some more colors, such as an orange blend of New Gamboge and Rose Madder Genuine. The best way to mix two colors is to squeeze some of one color out onto your white mixing area. Add a bit of water to make it more fluid and easier to mix. Then add the other color a little at a time until you get the orange that you want. If at some point you find that you have added too much of the second color, adjust the mixture by adding some more of the first one. When your mixture is concentrated, it may be too dark to see what it will look like when diluted to a wash. So test it as you go along by thinning small amounts of it and brushing it onto your board.

Helpful Hints

Here are a couple of helpful hints for when you are using pigment mixtures. When you are ready to use the mixture, don't use the brush that you mixed it with without thoroughly rinsing the brush first. Small residual amounts of unmixed pigment may remain in the brush hairs and surprise you when you begin to paint. And keep in mind that some pigments weigh more than others. This difference in weight can cause some color combinations—such as Ultramarine Blue and Alizarin Crimson—to separate vertically in the water. This separation can occur in your reservoir pool of paint, requiring you to stir it occasionally. If you lay a very generous wash of such colors onto your board, they could separate a little before they dry. If they do, don't worry about it; perhaps you will even like the effect that results.

Once your solution is ready to use, build up some layers of blue and then coat that with some layers of the orange. Try this combination of orange over blue in various ratios. Try it, for example, with just a few layers of the orange over many layers of blue. Then try it with many layers of orange over just a few layers of blue. Continue this way until you have explored all the possibilities and have learned how these two colors work together. You should find, for example, that if you coat the blue with enough of the orange, the blue will no longer look so blue. It will instead yield a deep shade of the orange. Now do this experiment in reverse order, layering the blue on top of the orange. Repeat this procedure with every combination of colors on your palette until you are entirely familiar with each one of them. When you feel you have accomplished that, you will be ready to begin an actual painting.

The Perils of Layering

Accidental Lifting

There are some technical hazards to beware of when you are painting layers. One of these risks is *unintentional lifting*. Unlike other painting mediums, watercolor paint is re-soluble even after it has completely dried. Thus, when you are applying a new layer of paint, the movement of the wet brush might accidentally loosen some of the paint from previous layers and move it over. The usual result is a small overly light spot that is right next to an overly dark spot. This can be a very disappointing surprise. The risk of accidental lifting increases proportionately as multiple layers accumulate.

There is no foolproof way to avoid inadvertent lifting, but there are some precautions that you can take to reduce the risk.

1. Wait until a layer is *completely* dry before applying the next one.
2. Don't be heavy-handed when you apply a layer; too much pressure from the brush can cause friction that pushes or pulls the film of paint right out of its place. Keep a light touch and measure your strokes thoughtfully.
3. Don't overwork an area when you are spreading in a new layer of paint. Avoid sweeping back over the same spot too many times. A second or third sweep of the brush may pick up paint that has been loosened by the first brushstroke.

All three of these suggestions have one thing in common: They each require plenty of patience.

Don't despair should unintentional lifting occur. This kind of mistake is much less troublesome and is easier to correct than other whopping blunders that you can so easily make when painting with watercolor.

To correct accidental lifting, first let the accident dry *completely*. This the hardest part, because your initial impulse is to get that seemingly hideous defect out of there as soon as possible. But haste could backfire on you and magnify the error. So be patient.

When the paint has fully dried, carefully lift out any overly dark parts where the paint has been pushed aside by the brush. Use the same method that you use for softening an unwanted rim (see page 70).Then fill in the accidentally lightened area little by little by softly touching it with the point of your brush. The brush should not be too wet. If you deposit a drop of paint that is too juicy, it may spread out and form a rim-ring, which will leave you right back where you started.

Color Bleeding

The second common peril of layering technique is *color bleeding*. This happens when you apply a juicy layer of color too close to a nearby area that is still wet. If the two deposits of paint make contact, one of them can suddenly blossom out into the other one, or they can bleed into each other. Just make certain that one layer of watercolor is completely dry before painting another one next to it.

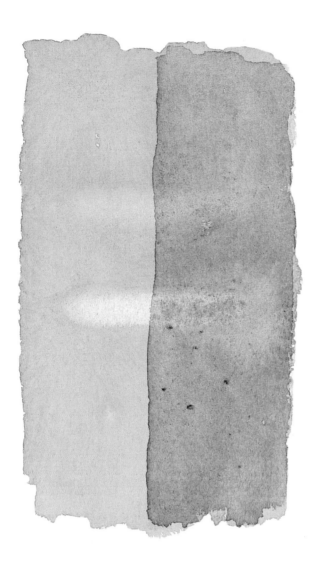

LIFTING PAINT

As a painting evolves, you may discover that you have painted some part of it too dark. You must thus know how to remove paint that you have already put down. To lighten an area, you must lift some of the pigment out. The darker an area is, the more difficult it will be to lighten it up by lifting.

In the illustration at left, you can see two places where I have lifted out paint. I did the top correction with a sable round and the bottom one with a small bristle brush.

I was able to get much more pigment out with the bristle brush, but it has an unfortunate side effect: The stiff bristles have tattered the surface of the board. This is acceptable if I don't intend to paint that place again. You can see the reason for yourself on the right. When I glazed over the blue with an orange wash, the tattered spot is too rough and absorbent. It has acted like a sponge and soaked up too much of the glaze. Not only has this made the corrected spot too orange, but it has drawn in some of the surrounding wash, creating a slight blue halo effect to its right. You can also see tiny orange specks below the corrected area where tiny particles from the board's surface have come loose and soaked up traces of paint. If you are not able to get the places as light as you want—even with a bristle brush—you may wish to use a white charcoal pencil. Gently rub the charcoal onto the surface of the paper, just as you would use black charcoal to shade in a dark area. The correction, if not too extensive, will be virtually unnoticeable. But the white charcoal will work well only if you are using it on a place that is already very light. If you use it on a place that is too dark, it will produce an unpleasant chalky appearance. So be sure to experiment with it first to find out for yourself what it will and will not do for you.

Remember to practice these techniques on your experimentation sheets with each of your colors before you try any in an actual painting. You will find that some pigments act like dyes and soak deep into the surface, making them difficult to lift out. Others do not sink as far into the board and are thus easier to lift. The best way to remove excess paint is to do it gradually, removing a little at a time and allowing it to dry between steps. This, by the way, can be rough on sable brushes, so you may want to keep a less expensive brush just for this purpose.

Rim-Ring

The third danger of layering paint is that of *rim-ring,* an effect that happens when a layer of watercolor dries with a bold rim around the edges and a faint middle. When you try to darken the middle with another layer of paint, the new layer will likewise spread out to form the same ring. You can resolve this problem by using your smallest brush with most of the watercolor removed. You do this by blotting the brush with a paper towel or tissue.

Then carefully and gently deposit the paint into the middle of the ring. (You may want to test it on your sacrifice sheet to make sure you have it right before you do it on your painting.) This will leave a deposit of paint that is not wet enough to migrate from the spot where you put it. You may have to build this up in two or three stages, letting it dry completely in between. If you want to remove the rim, you can use the correcting method that I have shown.

SOFTENING A RIM
Watercolor washes typically dry with dark, hard-edged rims of pigment around their edges. You may sometimes like the effect of the rim. But at other times you may want to remove it. In this example I eliminated the rim on the right side with a sable water-color round. After first allowing the wash to dry completely, I moistened the brush with clean water. I then gently dabbed the rimline with a scrubbing motion. As the brush picked up the paint, I wiped it on a paper towel. I repeated this process until the rim was gone.

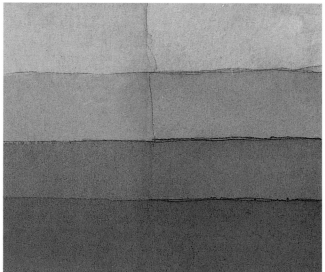

SMOOTHING OUT MULTIPLE RIMS
Sometimes when you are building up glazes—particularly if you are using washes—you can get a clutter of rims within a form that gives your painting a patchy or jumpy look. If you like it that way, just leave it. But if you do not like it, you can soften the rimlines. In this example I have smoothed out the hard edges of the left side of the bar with a very wet sable round brush. I did this with a circular motion over the surface of the paint, which lifts the rimlines up and spreads their pigment around. To prevent the lifting and spreading of too much paint, I keep a gentle touch and avoid overworking.

Working from the Pages of This Book

There are two things that are important to know about following along with the demonstrations on the following pages. Most importantly, you should realize that your version of each painting need not look exactly—brushstroke for brushstroke—like mine. The demonstration paintings are here to show you how to progress through a painting, but *you* are still the master of your own work, not me. Even if I were to do the same painting a dozen times, no two of those versions would look *exactly* the same.

You should also understand the principle of *evolution*. This simply means that no matter how much a painting is planned in advance, it is impossible to anticipate every last little point in your painting's color and tonal-value development. There is an interactive, give-and-take aspect to watercolor painting. You can plan ahead as much as you want; nevertheless, sometimes you must wait until a painting has evolved to a certain point before you can decide what to do next.

I have two more suggestions for undertaking your own versions of my demonstration paintings. First, read all the way through each demo before you begin. This will give you a vision of where your painting is going, and thereby help each step make sense to you. Second, keep some clean, dry tissue or a paper towel close at hand as you paint. You can use it to quickly remove a new layer of paint. Use the towel to gently *blot* the wet paint; don't try to *rub* it out. Just knowing that you can immediately correct such a mistake can help reduce your fear of failure.

Finally, one more suggestion, especially if you are a brand new watercolorist with no previous watercolor experience of any kind: Plan from the beginning to do each of the paintings in this book twice. This will not be a waste of your time. You can use the things you learned in the first version to help you do a better job the second time around. This is an important part of the learning process and should not be omitted.

Freewheeling It

Those who are best at loose, freewheeling techniques are those who have first mastered the more painstakingly slow stuff. This is how they learned control of the brush and medium.

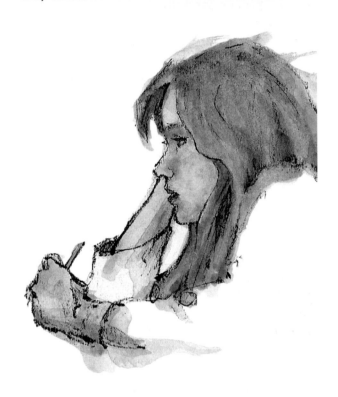

Demonstration One: Fisherman

In this demonstration I will show you how to decide *which* colors to use and *how much* of each you should use in your paintings. The diffused lighting yields some broad, simple and easily segmented masses of color that make the fisherman a good choice for your first watercolor painting of a human figure.

To paint the fisherman, you will try to approximate the colors that you see in the photograph on page 36. (Whether the colors in the photo are true to life does not matter here.) Your palette will be quite simple.

Palette
Raw Umber
New Gamboge
Burnt Sienna
Indanthrone Blue
You will use three two-color mixtures. The Burnt Sienna will serve as a handy, right-out-of-the-tube flesh tone.

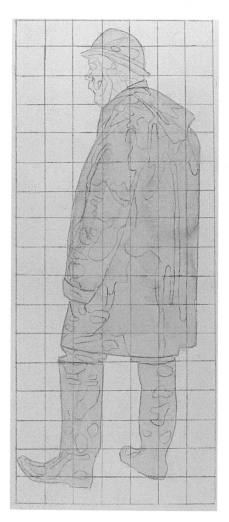

Step 1: Establish General Color Areas

Begin by applying a very diluted flat wash to each of the color zones in your underdrawing. (In my version, I am using a no. 6 Isabey retouching round, but a medium-size regular watercolor round brush will work, too.) Don't worry about the tonal values for now. At this point it doesn't matter which parts of each general area should be lighter or darker; you will deal with that issue in the next step. At this stage you are only deciding which color each zone will be.

Use very diluted washes, at least to begin with. As you lay down these washes, be sure to let each one dry completely before you lay down the one next to it.

Begin with the man's head. For the color of the hat, mix Raw Umber and New Gamboge. For the fisherman's head itself, a very diluted solution of Burnt Sienna will do quite well as a flesh tone. Lay the Burnt Sienna into the entire visible part of his head, including his beard and hair, and extend it up into the shadowed underside of his hat.

Paint the collar with pure Indanthrone Blue. For the raincoat, use a green mixture of Indanthrone Blue and New Gamboge. For the parts of his pant legs that show between the coat and boots, use pure blue again.

For the boots, use a mixture of Raw Umber and Indanthrone Blue. This will yield a drab gray tone that will work well as your "black." Use this same mixture in the glove. You have now chosen the colors that you will use to do each part of this painting. This leaves you only one more major decision to make—*how much* paint you should put in the different parts of the painting. Now you must develop your tonal values.

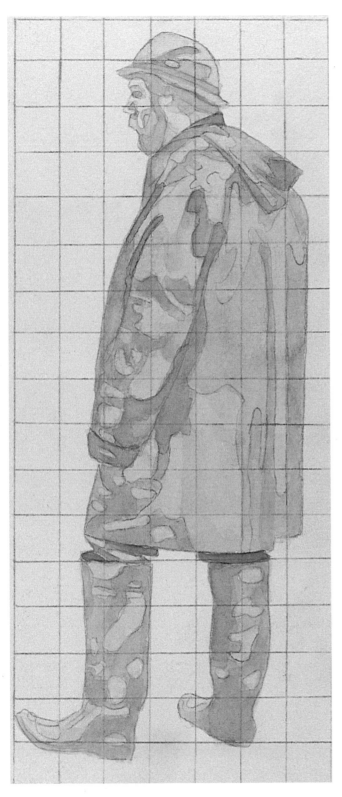

Step 2: Begin Modeling

Begin building up the various tonal values in the figure form. Use the underdrawing as a map with which to locate the areas that need to be darker. Then begin lowering their tonal values with successive layers of diluted paint. Use pure Raw Umber to develop the darkest places on the head, such as the hair and beard. Be cautious. By progressing slowly and carefully, you can significantly reduce your risk of failure. You will shade down some places more than others. Keep the photograph at hand (on the left side if you are right-handed; on the right side if you are left-handed) and refer to it constantly. It will tell you how dark each place should be. Remember that your underdrawing is only a map to help you find your way around as you paint. It is not the last word on what your final painting should look like—and you are not forever bound to it.

Step 3: Conclude Modeling

At some point, you must decide that you have developed the tonal values enough. You are not obligated to make your lowest values as dark as the ones in the reference photo on page 36. You can see that I have chosen not to darken them all the way down, particularly in the boots. When painting the fisherman's glove in my demonstration painting, I alternated its washes between the raincoat green and the boot gray. I have also occasionally brought some of the boot gray washes up into the blue jeans. I did this to give a little more variety to the colors in the figure.

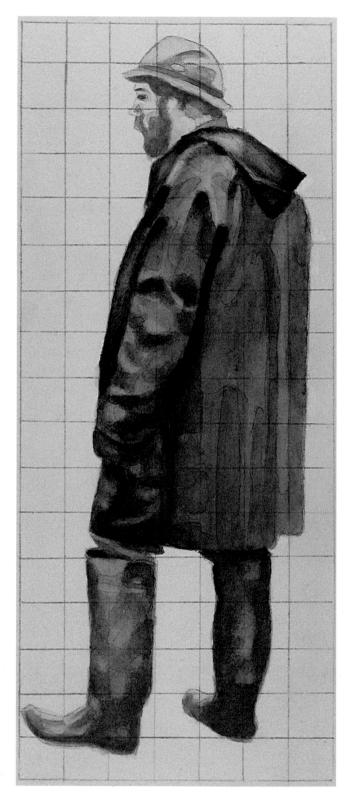

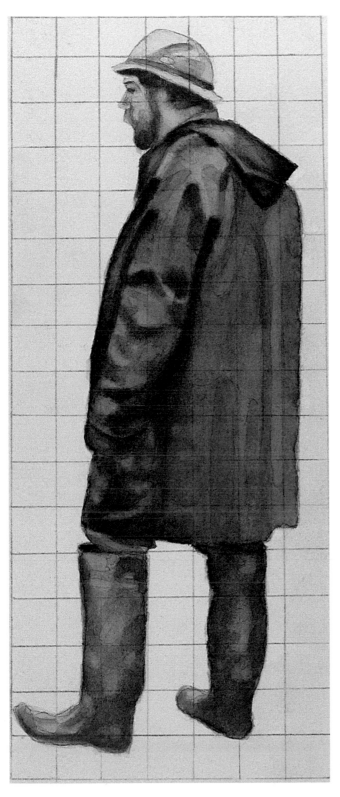

Step 4: Add Finishing Touches

Now go back over the boots and raincoat with light, flat washes of pure Indanthrone Blue. Also, put a touch of the blue in the receding areas of the head—the throat, the back of the neck and the eye area—and the back part of the hat. Use the blue to darken the hatband, beard, hair and the area just under the rim of the hat.

Bringing in the blue this way serves two purposes. It unifies the various segments of the figure by making them look like they all belong together in the same picture, and improves the color quality of the painting as well. The thin, flat layers of blue will show up the most in the lightest areas of the coat and boots, but will be virtually undetectable in the darker areas. This causes a subtle variation in the hues that simulates the interplay of light and color that occurs in the real world. The slight variety of hues also keeps the broader surface of the raincoat from being too monotonous. With that your painting of the fisherman is complete.

Fisherman
9½" × 4½" (24cm × 11cm)

Demonstration Two: Contestant

Having completed the fisherman, you are ready to do the rodeo contestant. The imagery will be more complex, but the process will be very simple. I will make it easy for you by breaking it down into uncomplicated, manageable steps.

Because the reference photo on page 40 is black and white, and because I took it so many years ago, I have no idea what colors the cowboy's clothes were—except for his blue jeans. As an artist, you are not obligated to paint the original colors anyway. You can choose whatever colors you want. For this demonstration, I have selected a palette that will help you to put color theory into practice. As with all the paintings in this book, your method of painting will be layering.

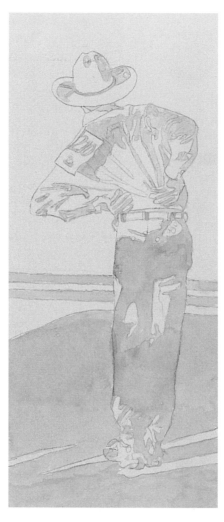

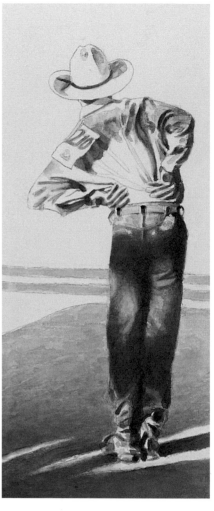

Step 1: Lay in Initial Wash
Lay in a light violet wash mixed from Alizarin Crimson and Ultramarine Blue. Paint the wash into every place in the picture that will be dark—including all the shadows.

Step 2: Begin Tonal Modeling
Now build up all the tonal shapes just as you did in the fisherman. When you finish this step, you will have a monochromatic underpainting on which you will paint the rest of your colors.

Palette
Alizarin Crimson
Ultramarine Blue
Quinacridone Gold
Raw Umber
You will use one color mixture.

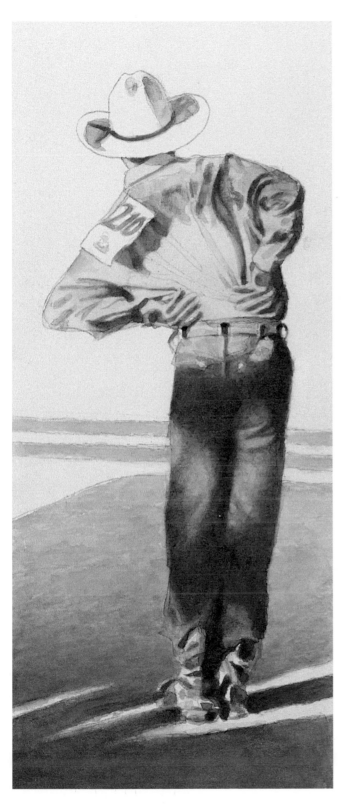

Step 3: Introduce Color Complement

The underpainting is now ready for the rest of the colors. First, bring in the Quinacridone Gold. A yellow, this is the complementary hue of violet; in other words, it is opposite violet on the color wheel. Lightly layer the yellow into all the shadows, over the entire shirt, over the hands and over the part of the neck that shows underneath his hat.

Step 4: Develop Color Complement

Paint the shirt yellow, and continue to develop the tonal values —which includes lifting whenever needed—with the Quinacridone Gold. As you do, take note of the magically beautiful effect that you get by glazing a warm color over its cool complement. If you were to try to duplicate this appearance by mixing the violet (which is already a mixture itself) with the yellow before you lay down your paint, you probably would get only "mud." But layering technique helps you to avoid muddy colors, which is one reason I am having you use it. Observe, too, that when you have glazed enough of the yellow over the violet in the shirt folds, they no longer look violet. They just look like dark shadows in the yellow shirt. This is important because there is no such thing as *dark* yellow, and you cannot shade yellow down with black, because that will produce an undesirable green hue. You must darken yellow with its color opposite—violet.

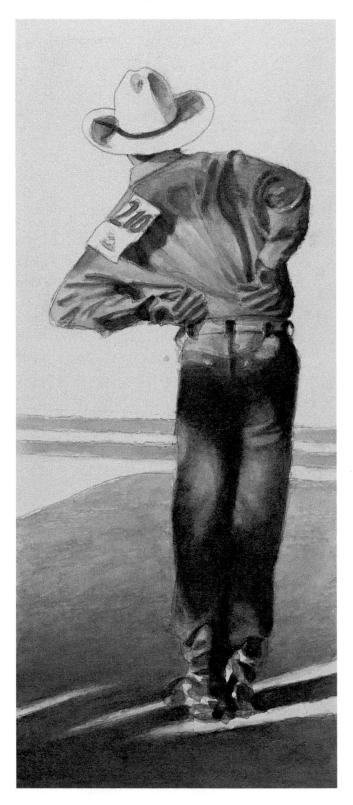

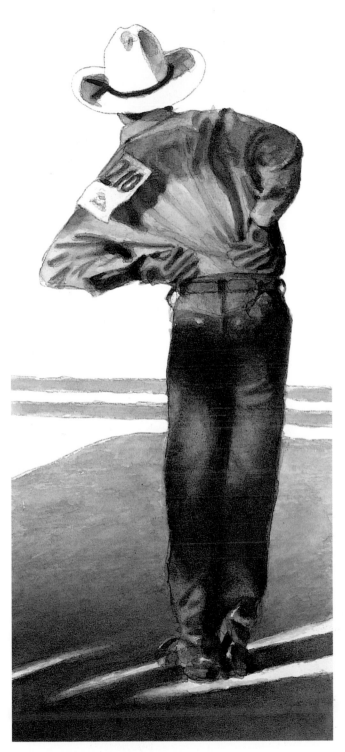

Step 5: Introduce Remaining Colors

First, bring in the pure Ultramarine Blue. Most of it, of course, will go into the cowboy's jeans, but also add a little to his hair and the hatband. Next, glaze some Raw Umber over the boots, belt, hair and hatband. Finally, bring in the red—the Alizarin Crimson. Use it to paint the bandanna that is hanging out of the cowboy's pocket. Glaze a little of it over the hands and the side of his neck under the hat to produce the flesh tones. In my version, I felt that the red also needed to be repeated in the lower part of the composition, so I exercised my artistic license and glazed some of it into part of the boots. With this, the painting is complete.

Contestant
8¾" × 4½" (22cm × 14cm)

Demonstration Three: Four Men

This time, you will be working with the multi-figure under-drawing of the four men in the dirt lot (see page 43). I will offset the increased figure complexity by simplifying the palette and pictorial details. With this project, I will show you how to make sure that the painted figures all look like they belong in the same picture together. This concern for compositional unity is unimportant when looking at a photo of the four individuals; people consider photography to be infallible, so if they see four men together in the same shot, it is presumed that they all really were there at the same time. Artistic depictions are, to the contrary, considered to be quite fallible. This places a burden upon you—the artist—to convince the observer that you have got it right. In this demonstration, I will show you how to do that.

Your palette for "Four Men" is rudimentary, but I think that you will be pleasantly surprised to see the variety of hues you can get with just these two pigments.

Palette
Cobalt Blue
Quinacridone Sienna

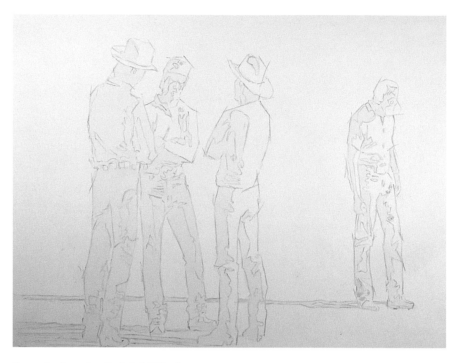

Step 1: Lay in Initial Wash
Lay a wash of Cobalt Blue into all the shadow areas as you did with the violet mixture in Demonstration 2 (see page 78). Also, put some of the wash into the entire shirt of the man on the left side of the picture.

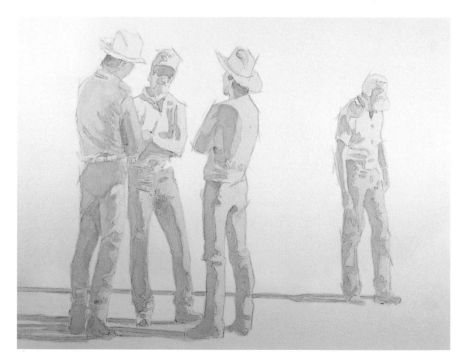

Step 2: Begin Tonal Modeling
Build up the basic tonal shapes with the blue to the extent that you see here. It is not necessary to make your lowest tonal values as dark as those in the reference photograph on page 43.

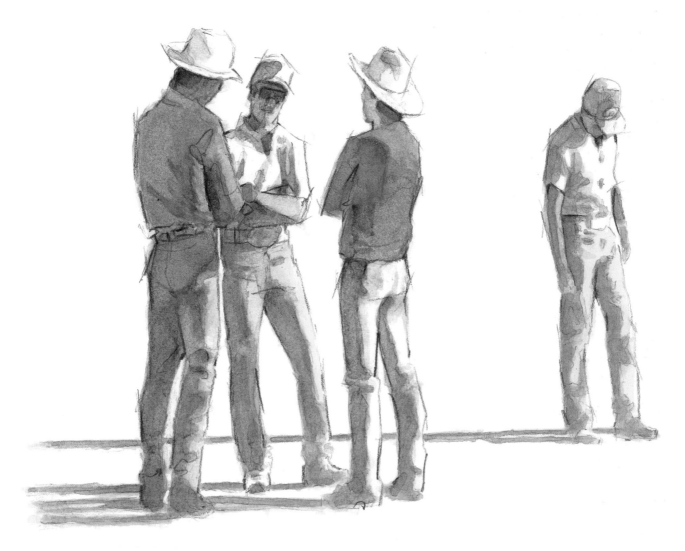

Step 3: Add "Sunlight"

Bring in the Quinacridone Sienna. Apply it selectively as I have in my version. In the shirt on the far left, for example, I have glazed just enough to yield a somewhat brownish hue. You can see a similar effect in the flesh tones and hair. By varying the combinations of these two pigments and the white of the board's surface, you can achieve a surprising diversity of colors.

Four Men
8½" × 10½"
(22cm × 27cm)

Demonstration Four: Child with Pigeons

In the previous demonstration, you learned the importance of making sure that multiple figures look like they all belong in the same depiction. Now, I will show you how to relate a figure to its overall visual context—to its background—and to the other elements within the composition.

There are three ways to achieve compositional unity between a figure and its setting.

1. *Consistency of lighting and shadows.* The figure and other elements must all be illuminated by the same quality and direction of light. It would look odd to show a figure that is lit by a single, strong directional source of light right next to someone or something that is covered with soft, diffused light. The only exception would be a scene where one figure or object is positioned out in the light while the other is in shadow. Likewise, the cast shadows must be consistent in quality and direction.

2. *Chromatic consistency.* The color of a person's flesh tones, hair and clothing must harmonize with the overall color scheme of the general scene, especially in its shadows. Without this, a figure could look like it has been cut out and pasted onto the picture.

3. *Pictorial perspective.* Representational art requires the artist to create the illusion of a three-dimensional space, and the figure(s) must appear to occupy a believable position within that spatial depth. In other words, it needs to fit into the picture.

In *Pigeons*, you will use all three of these devices. I will, for purposes of clarity, present them to you in a very plain and elementary way. Your colors are, by design, a palette of earthy pigments.

Palette
Raw Umber
Indanthrone Blue
Burnt Sienna
Yellow Ochre

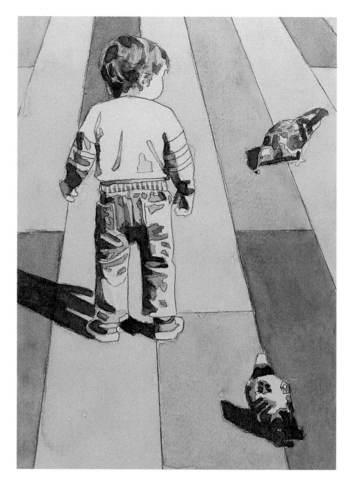

Step 1: Establish Tonal Values
With Raw Umber, begin by establishing your tonal shapes just as you did in the previous paintings. Use Raw Umber to paint the deck boards as well. Vary the darkness of the boards, though, to avoid visual monotony. In my version, in the lower pigeon on the right, I have not distinguished between the darkest parts of the bird and the shadow next to it. In the small reference photo (see page 45), the distinction was not very clear; they combined to make a single dark area. That won't really matter in the finished painting anyway, so I will let that part of my painting just be vague. You can do this, too. I have also decided to omit the lower horizontal fold of the shirt (the one at his waistline—see page 45). I replaced it with little vertical lines to suggest the gathers of the elastic waist of his pants. You can do it just as easily either way. This establishes the tonal shapes of the picture.

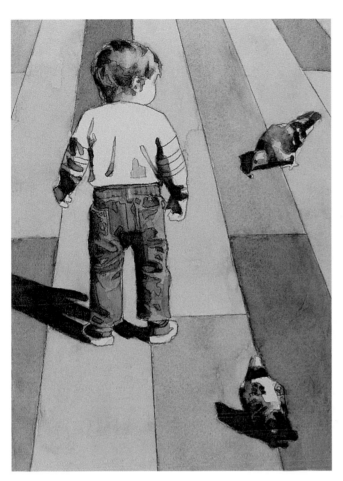

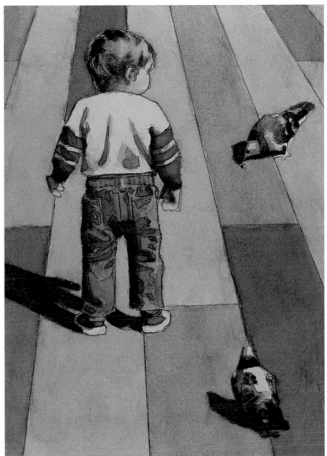

Step 2: Add Cool Tones

Now apply your Indanthrone Blue. Although this is a relatively warm color for a blue, it is still the coolest color on your palette. Use it to paint the pants. (Indanthrone Blue is the perfect pigment for painting blue jeans.) Look at my version before you do, though. Observe that I have varied the amount of blue across the surface of the trousers. By doing it this way, I can simulate the real-life appearance of worn jeans. Use the blue to further darken all the lower tonal areas such as on the pigeons, in the boy's hair and in the shadows. Glaze some of the blue over the floor planks as well, but again, vary the number of layers from one board to the next for the sake of visual diversity.

Step 3: Bring in Warm Tones

Next, mix an orange with your Burnt Sienna and Yellow Ochre. The orange, being the color opposite (complement) of blue, will render some pleasant chromatic effects. Lay it into the darker rings of the shirt sleeves and into the darker part of the shoes. Put some into the shadows of the shirt, too. Glaze some over the planks in varying amounts. Use the diluted orange as the flesh tone in the face and hands. At this point in the painting's evolution I have decided that the head does not stand out enough against the background. I can resolve that problem by increasing the contrasts within the form of the head and by increasing the contrasts between the head and the planks behind it. In the next steps, I will take care of that.

Step 4: Split Warm Tone

Now *split* the orange color by using its component colors separately. Glaze Burnt Sienna over the dark rings of the sleeves and the darkest part of the shoes. Glaze some of it into the shadows of the shirt as well. Use the Yellow Ochre as the main color of the shirt. Lay some of it (but not too much) into the hair and add some to the sunny side of the darker part of his shoes. I have decided that there is still not enough contrast between the head and the background. So I increase the contrast within the head and between the head and background by lifting out some of the paint in the lighter parts of the head. I will not be painting this area any more, so I use my bristle brush to scrub some of the color out. I also heighten the contrast between the head and the background by glazing the planks behind him a little darker with the yellow. That requires me to adjust some of the other planks in the scene so that the composition will not be off balance. As your painting progresses, keep in mind that *you* are the boss of your own work; you are not obliged to do everything exactly as I do. If you think that your version, for example, does not require the same adjustments that my version does, you do not have to do them. Remember that my paintings are here only to illustrate the ideas that I am teaching you.

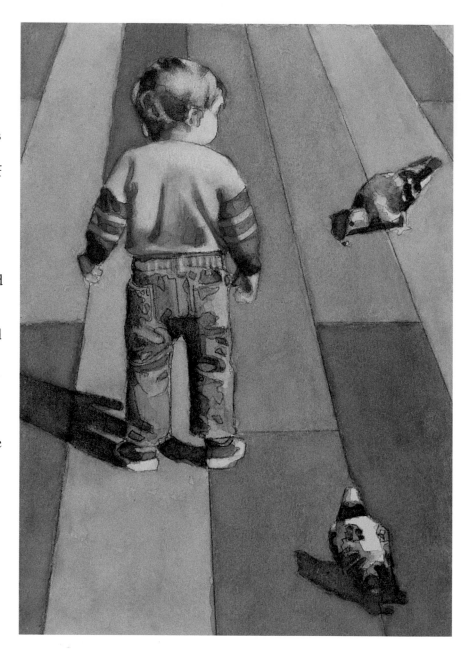

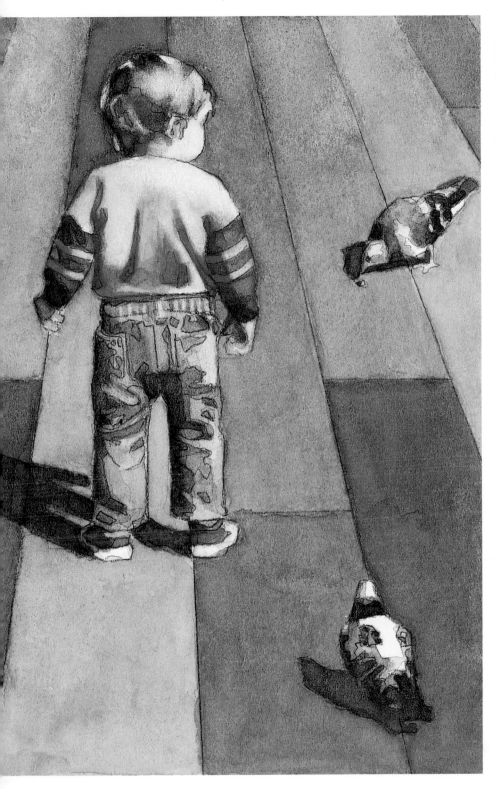

Step 5: Add Finishing Touches

Add the finishing touches with Indanthrone Blue. You can put more of the blue in the darkest shadows, including in the hair, and glaze a little of the blue over all the floorboards. The blue will help you create the appearance of depth in your painting. Glaze extra layers of blue over the top background of the scene so that it gradually gets darker as it goes back. This will enhance the illusion of three-dimensional space in two ways. Blue, for one thing, is a cooler color than the other pigments. Cooler hues appear to recede, whereas warm colors seem to advance. Your painting is now warmer in the foreground and cooler in the distant background. The extra glazes of blue, moreover, darken the more remote background. Lower tonal values seem to recede, whereas higher tonal values appear to advance. This is part of what is called *atmospheric perspective*. I have lifted out a little more pigment in the lighter areas and even lightened it up a little more with the white charcoal pencil.

Pigeons
7½" × 5½"
(19cm × 14cm)

Demonstration Five: Swimmers

In this painting, I will introduce you to a more freewheeling approach to watercolor sketching. It will be a safe introduction, one which will not require you to entirely depart from the security of your structural underdrawing. You can draw on the wild side just enough for you to get the feel of it and see if you like it.

I will prescribe a simple palette once again—this time just the three primary colors. These are the hottest red, yellow and blue that you have on your palette. They will be just right for portraying a scene that I drew on a bright summer day.

Palette
Indanthrone Blue
Quinacridone Sienna
Quinacridone Gold

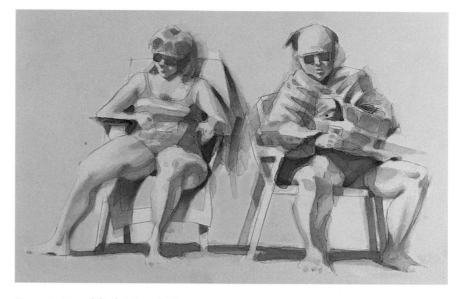

Step 1: Establish Tonal Shapes

Using Indanthrone Blue, develop the tonal values of the picture as you have done with the previous paintings. This time, though, be a little more relaxed in the way you apply the layers of paint. You still have the security of the underdrawing (See page 49) to eliminate guesswork, but don't feel so tightly bound by it. Loosen up a bit. You really have nothing to lose but your inhibitions. Examine my version of the underpainting. Look at all the places where my brushstrokes overshot the mark. Take particular note of the dark freehand stroke just under the woman's right arm. This was an accident—a surprise. When I brushed it on, I didn't realize that the brush hairs still had some undiluted paint hidden in them. I liked the way it looked, so I left it there. If you are still afraid of making terrible mistakes, do this underpainting with a crumpled paper towel in your free hand. If you don't like a particular brushstroke, you can quickly dab it out before it begins to dry. Remember that this is just a sketch—not a tight, meticulous rendering. I also have glazed over the flesh areas with an orange mixture of red (Quinacridone Sienna) and yellow (Quinacridone Gold). I have added shadows to the woman's arms and legs to make them more consistent with the shadows on the man.

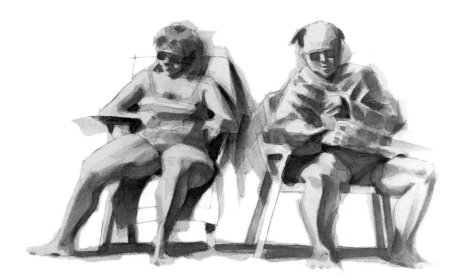

Step 2: Introduce Warm Tones

Continue to develop the tonal values throughout the scene with the orange. Be sure to use plenty of it in the shadows of the man's towel. Use it as the base flesh tone. Don't be too restrained with your brushstrokes.

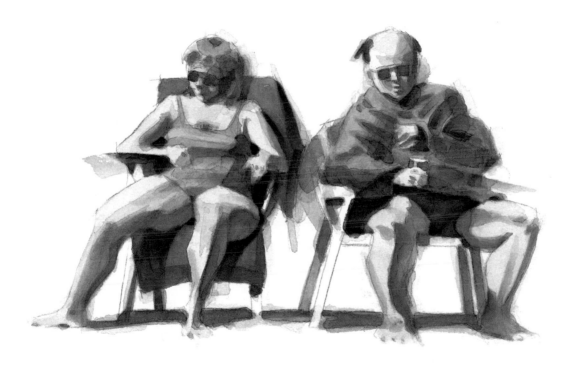

Swimmers
6½" × 10"
(17cm x 25cm)

Step 3: Split Warm Tones

To finish the sketch, use the pure red and yellow. Add the red to the woman's towel and to the man's swimming trunks. Notice that the red glazes over the blue underpainting make his swimming trunks look violet. Now glaze the yellow in his towel and her swimsuit. Notice that the yellow over the blue underpainting makes it look green. The shadows in the man's towel do not look green, however, because of the glazes of orange between the blue underpainting and the yellow overpainting. As I have gone along, I have added a few brushstrokes of the different colors to the space between the chairs to better integrate the two figures into a single composition. We created a surprising variety of hues with just three pigments.

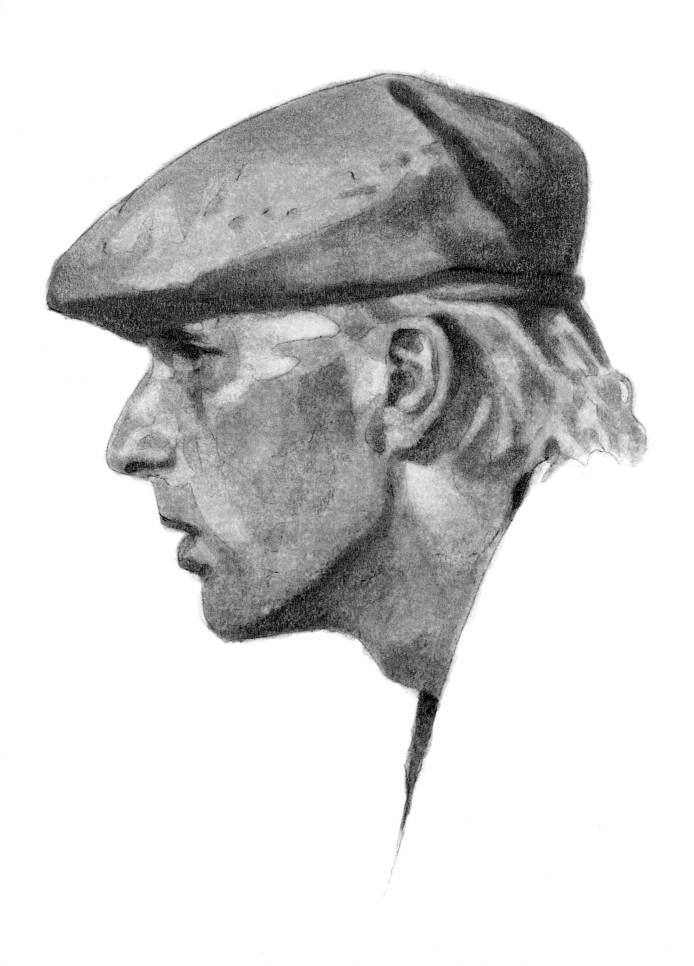

ENLIVEN YOUR PORTRAITS WITH BOTH VIBRANT AND SUBTLE COLORS

In this chapter, you will paint watercolor portraits with the under-drawings that you drew in chapter 4. I will ease you into portraiture gradually with an easy preparatory exercise. This exercise will focus strictly on the development of the tonal shapes. You will do a mono-chromatic (one-color) exercise that will teach you how to model the individual facial features and how to integrate them into a lifelike face.

Remember that the portraits in this book themselves are not your ultimate goal; these portraits are here for you to learn how to do portraits of your own people. So do your best to get them right, but give yourself some slack too. Allow yourself the leeway to make some errors—even many errors—as you go through the process of learning.

Robert
8" × 6½" (20cm × 17cm)

The Portraits

I have done everything possible to make the portraits themselves easier for you to do—and to ease your fear of failure. You will, for example, be working with simple poses. And your first portrait will focus on just the face, and nothing but the face. Your scope will gradually expand from there, eventually to include more parts of the model.

I have, as well, omitted or simplified the background elements in your portrait projects. This will focus your attention, time and effort on the most important part of a portrait; the person you are painting. Because you will have less to do in each painting, you will have fewer chances to make mistakes. This will, in turn, help reduce your fear of failure. And, likewise, you will be able to produce the flesh tones with studied caution as you build them up in measured layers.

In this chapter, you will use the surfactant that I recommended in chapter 1 (see page 16). This additive can help you paint a more natural-looking illusion of smooth human skin by preventing the accumulation of hard edges from each layer of paint. You won't need much surfactant; just add it "dropwise" to your watercolor solution (testing it as you go) until you have enough to do the job. Do this on your sacrifice sheet. You will find that it doesn't take much surfactant—Just a little dash will do.

The surfactants that I have recommended are actually made for use with fluid acrylics. There is a surfactant made specifically for watercolor called *ox gall*, but I don't think it works as well. Surfactants of any kind, even with the rougher kinds of cold-pressed papers, don't work with rough paper surfaces because a heavily textured surface is much too resistant for the surfactant to overcome. So if you are using a rougher paper or choose not to use the surfactant, you may wish to reduce the rim lines with the method that I showed you in chapter 5 (see page 72).

There is a technical risk with the use of surfactants: overspreading. Surfactants work by reducing the surface tension between the paper and the paint. Without the normal resistance from the paper's texture, the solution (and the pigment within it) spreads out further in every direction. Sometimes it might spread out much further than you had intended, straying out of bounds and sprawling over into adjacent areas. This is a problem especially when using a loose wash and when applying paint to a bare (or almost bare) surface. As the layers of paint build up, subsequent layers are less likely to overspread. The best way to minimize the risk of overspreading is to reduce the amount of paint solution in your brush.

For the following portraits I will give you simple, designated palettes and methods to work with. I prescribe a variety of color combinations and procedures only for the purpose of doing these practice portraits. This does not mean that any of them is the only palette or method for getting a particular flesh tone. My objective is to show you how to choose and use your own flesh tone palette.

Before you begin painting each portrait, I suggest that you first read through the step-by-step instructions. This will give you an idea of where the painting is going as you complete each step.

As you follow my demonstration paintings, you will find some steps labeled *Model the Form*. Sometimes there will be two illustrations with these steps. The first one will show you the modeling process at an intermediate stage; the second illustration will show you what the painting should look like at the end of that step. This should make the modeling steps easier to follow.

Countertoning and Overtoning

In this chapter, you will expand upon two concepts that you have already used in the previous chapter: *countertoning* and *overtoning*. A countertone is the chromatic *complement* of the base flesh-tone hue. In other words, it is the color that is opposite the base flesh tone on the color wheel. You used a countertone of yellow, for example, when you glazed it over the violet underpainting of the cowboy contestant. Now you will use countertoning in more subtle ways.

You can use a transparent countertone glaze to moderate the base flesh tone and to subdue it. With this, you can make your flesh tones look more life-like and natural.

You may use a countertone to paint the shadows by glazing it over the darker areas of the base tone. You can also use it to render some colors of hair. Because the countertone is the chromatic complement of the base tone, these two separate colors can offset each other. This will result in a hue that looks not quite like either the base tone or the counter-tone. It will, instead, look more like either a neutral gray or a brown—or even black. Whether it will tend to look brownish, grayish or blackish will depend on your choice of pigments and on the ratio by which you glaze one over the other.

An overtone glaze is a transparent blanket of color that you apply on top of a base tone after you have established all the tonal shapes. An overtone, unlike a countertone, is not the chromatic complement of the base tone. It is, instead, a color near the base tone on the color wheel. Adding an overtone will shift the hue of the base tone. An overtone of red applied to an orange, for example, will give you a reddish orange. How red it will be, of course, will depend on how much red you glaze over it. You have already used an overglaze in chapter 5 when you painted a coat of pure blue over the green raincoat of the fisherman. You now will apply this principle to painting skin colors. You will use it, for example, to put some pink into parts of some faces.

A final overtone glaze, evenly distributed over the surface of a figure's skin, will not only modify the original base tone, but will also modify any inter-mediate layers of color (such as a countertone). The tonal ratio of the different color layers will thus vary from one part of the face to another. In one place, for example, the proportion of the overtone will be greater than that of the base tone. In another area, there may be more base tone than overtone. Such differing ratios of color will produce subtle modula-tions in the flesh tone, but at the same time will unify the overall hues of the skin, making sure they look like they all belong on the same face. This will make it easier to paint those beautiful, natural-look-ing flesh tones that bring a portrait to life.

Preliminary Exercises

If you have little or no previous experience with portraiture in any medium, the following exercise will prepare you for doing portraits in watercolor.

Preliminary Exercise: The Eyes, Nose and Mouth

In this exercise, you will paint actual human facial features. But you won't be concerned with flesh tones yet. This is a *monochromatic* exercise in which you will concern yourself only with modeling forms with contrasting tonal values. You will therefore use just one unmixed color: Burnt Umber. Your brush should be an Isabey no. 6 retouching round or an approximate equivalent.

This exercise will teach you how to use tonal values to define simple facial features: the eyes, nose and closed mouth. I also show you how these features are visually integrated into a face by their interlocking tonal shapes.

Prepare for this exercise by copying the configuration of lines at right. Remember that you don't need to make your lines as dark and bold as mine.

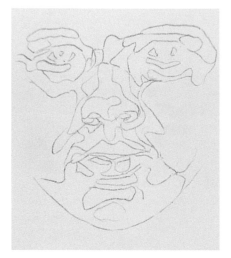

Think of this underdrawing as a relief map that will lead you across the terrain of the model's face.

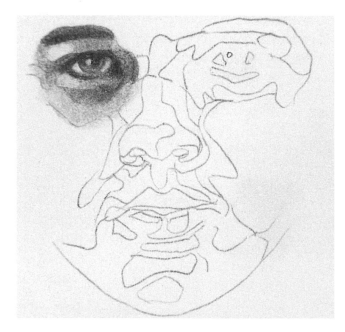

Step 1: Paint Right Eye
Paint the underdrawing of the right eye in the same way that you did the figures in chapter 5. Start with a light toning wash and then develop the tonal values by careful layering until your painting of an eye looks like mine. Paint *only* the right eye—until it is complete.

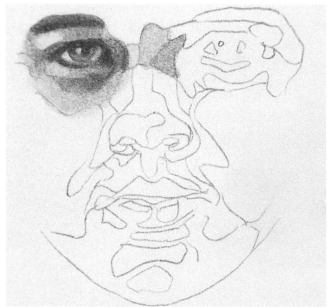

Step 2: Bridge Gap between the Eyes
When the right eye is complete and dry, paint the bridge of the nose in the same way. Develop the tonal values in the bridge only to the extent that I have done here.

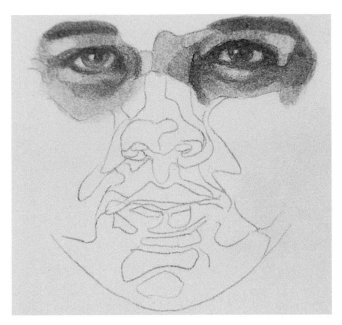

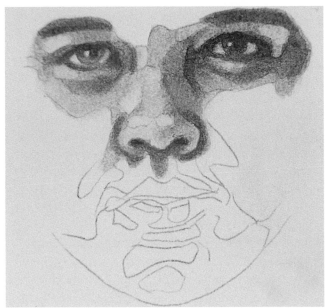

Step 3: Paint Left Eye
You can now paint the left eye and finish the tonal values in the bridge of the nose. Observe how the bridge, being between the two eyes, integrates them into a single unit. It is literally a bridge: a visual bridge that links the two eyes, relating them to each other in the face.

Step 4: Paint Nose
Now paint the tonal shapes that define the nose. When you have done this, pause again. Notice how the contrasts of the tonal values create the illusion of a three-dimensional form.

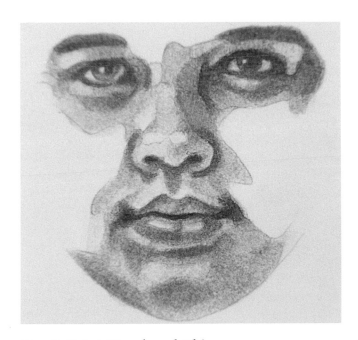

Step 5: Paint Mouth and Chin
Next paint the tonal shapes that define the mouth and chin. Once again, pause to review your work. You have not only painted the individual facial features, but you have also united them into a face.

Step 6: Complete Face
Here I have filled out the rest of the face. This is not a step in the exercise. I just want you to observe how the outer contours envelop the features, creating a beautiful and lifelike human face.

Demonstration Portrait One: Elaine

To paint your portrait of Elaine, use the same pigments (Rose Madder Genuine, New Gamboge and Cobalt Blue) and simple mixture (Rose Madder Genuine and New Gamboge) that you used to paint the flesh-tone scale in chapter 2 (see page 29). You will use the three round brushes and your surfactant. As you do this exercise, rely on the guidance that I give you in my version of "Elaine" and on the experience that you gained in doing the preliminary monochromatic exercise.

Don't be concerned that the flesh tones in your portrayal of Elaine are not "true"—nor that her eyelashes will be blue. I did it this way to simplify it for you. The most important thing is that you are now well on your way to painting beautiful, lifelike portraits.

Palette
Rose Madder Genuine
New Gamboge
Cobalt Blue
Your base tone is a simple mixture of Rose Madder Genuine and New Gamboge.

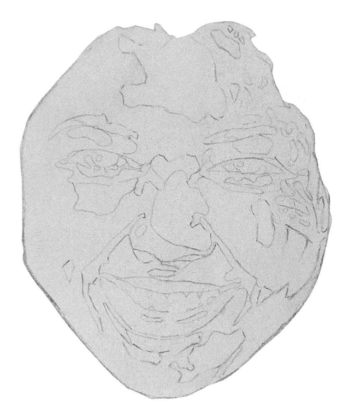

Step 1: Tone Face
Mix a flesh tone with the Rose Madder Genuine and New Gamboge. With a medium round brush, apply a wash of it (without surfactant) to the entire face, including the "whites" of the eyes and the teeth.

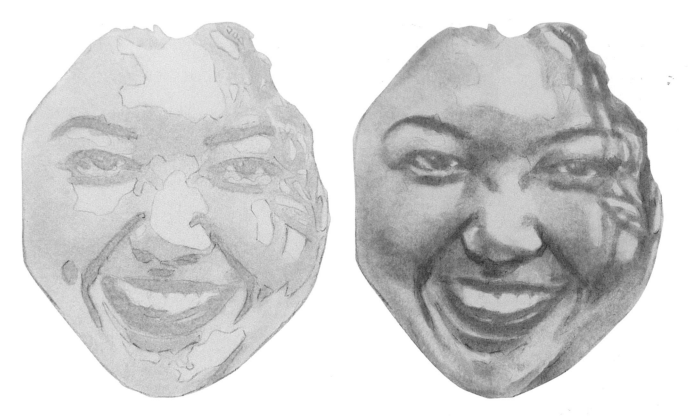

Step 2: Model Form

Add surfactant to the flesh-tone mixture. With a no. 6 Isabey retouching round, model the surface forms of Elaine's face—including the eyebrows. Treat each eyebrow as a singular form rather than trying to paint the individual hairs within it. Develop the flesh-tone modeling to the same extent that I have done in my demonstration version of this painting.

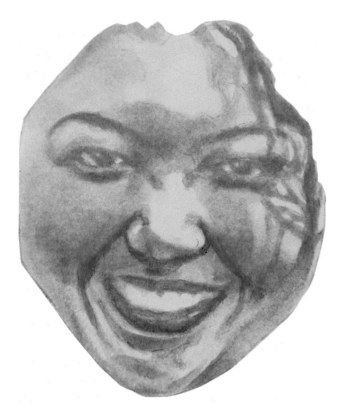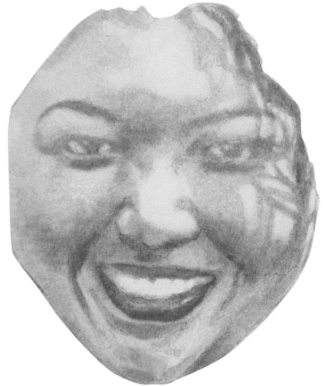

Step 3: Add Pure Red

Now use each of the two flesh-tone components separately with the same brush. First use glazes of the Rose Madder Genuine with surfactant to paint the red part of the lips. Then use thinner glazes to paint the pink part of the cheeks. Also glaze some of the red into the furrows between the cheeks and upper lips that run down from the sides of the nose and the sides of the mouth. Glaze some of the red over the middle-lower forehead area just above the bridge of the nose and over the center of the chin, and add some red glazes to the shadows of the hair on the side of Elaine's face.

Step 4: Add Yellow

Now use the yellow (the New Gamboge) with the surfactant. With the same brush, glaze some of it over the lower sides of Elaine's chin and jawline. Add a touch of yellow to the underside of the nose. This creates the effect of reflected light coming up from something below her face and adds more color variety and visual interest to her flesh tones.

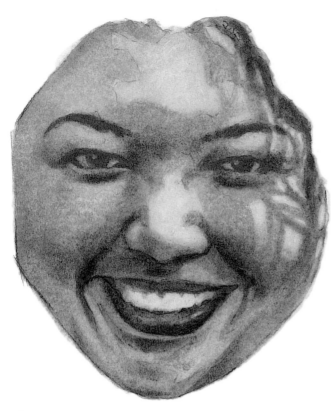

Elaine
6¾" × 4½" (17cm × 11cm)

Step 5: Complete Painting

To finish the painting, bring in the Cobalt Blue with the surfactant. Use it to paint the crevice shadows of the face: the nostrils, the corners of the mouth and the furrows between each cheek and the mouth. Also use it to paint the small dark places between her teeth and lower lip. A faint touch of the blue over the far right end of her teeth (*her* right side, not ours) will help to turn it back into the shadows.

Darken these areas cautiously, using relatively thin solutions of the paint. Add a little of the Cobalt Blue to each of the places that are medium in tonal value: the slight folds beneath her eyes and under the lower lip, and the darker areas in the flesh tones of her upper lip. Use it to darken the edge of the red part of the lower lip and parts of the hair shadows on the side of her face.

Use the Cobalt Blue to finish the eyebrows and to paint the detail in Elaine's eyes. As with the eyebrows, don't try to paint the individual eyelash hairs or try to differentiate within the dark areas of the eyes. Just treat the dark parts of each eye as a single, solid unit.

Finally, apply very thin glazes of Cobalt Blue to the parts of her face that are on the opposite side of the primary light source, such as the outside areas of her right cheek, eyelid and temple, the right side of the nose and the inside part of her left cheek.

Demonstration Portrait Two: Robert

For your portrait of Robert, you will stay with your now-familiar palette of Rose Madder Genuine, New Gamboge and Cobalt Blue. You will mix your base flesh tone from the Rose Madder Genuine and New Gamboge. Your brushes will be your three water-color rounds.

In this portrait, you will paint with a different approach. Rather than glaze your blue countertone *over* the base flesh tone, as you did with the last project, you will paint it *beneath* the base flesh tone. You will first use the blue to develop the tonal shapes in the form of an underpainting over which you will glaze the base flesh tone.

Palette
Rose Madder Genuine
New Gamboge
Cobalt Blue
Your base flesh tone is, again, a mixture of Rose Madder Genuine and New Gamboge.

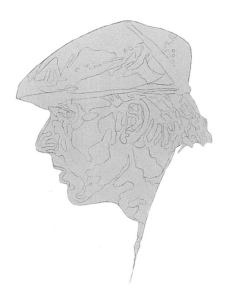 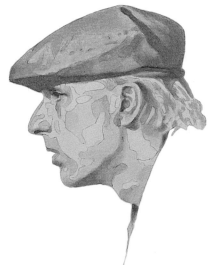 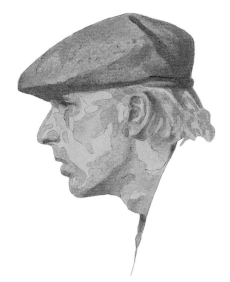

Step 1: Establish Underpainting
Use a thin solution of Cobalt Blue—without the surfactant—to tone the entire image, including the cap and the hair.

Step 2: Begin Modeling
Use Cobalt Blue with the surfactant to establish all the tonal shapes. Don't build up the tonal values too much though—just enough to identify the surface forms. Paint the hair in the same way that you do the face and cap. Look for the major tonal shapes that are created by the shifting directions of the locks of hair. Don't try to paint every minute detail of the hairs. That wouldn't work, and it would just frustrate you.

Step 3: Paint Base Flesh Tones
Lay in a wash of the orange flesh-tone mixture without the surfactant over the entire image, including the cap and hair.

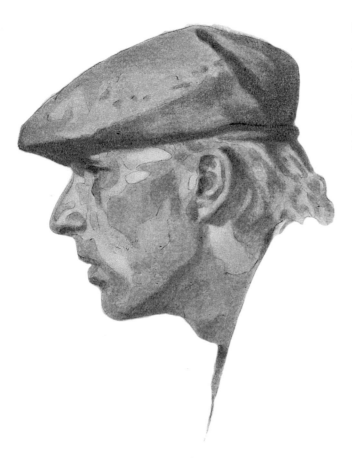

Step 4: Model Form

Add surfactant to the mixture and complete the modeling of the tonal values. Study my version of the portrait before you paint to see how I have done it. I have a higher proportion of blue to orange in the cap than I do in the skin. This ratio of the two complementary colors yields a third tone: a vibrant gray. This gray would not be nearly so dynamic if I had mixed it by stirring the colors together before I used them. Don't forget to layer some of the flesh-tone orange into the separation space of Robert's collar, right below the front of his neck.

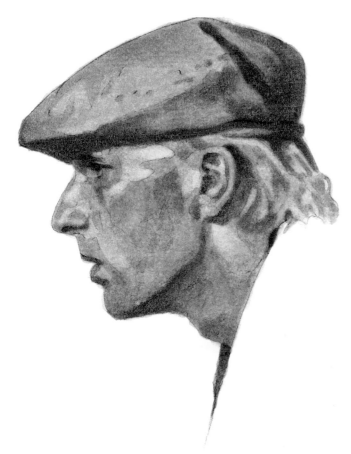

Step 5: Add Final Touches

You can now use each of the flesh-tone components—the pure red (Rose Madder Genuine) and the pure yellow (New Gamboge)—with the surfactant. Use the red discreetly. Glaze some of it into the cheek and into the triangular area between the cheek, eye and nose. Paint some of it into the upper-front part of his chin and into his throat, and add a touch of it in the lobe of his ear. Use the red to paint the vermilion part of his lips. Glaze some of the yellow into his hair, but do it sparingly; otherwise it will look outright yellow. Do any lightening (by lifting and/or with your white charcoal pencil) that you deem necessary. In my version I have particularly lightened the area of the neck that is just below the ear. I did this because I like to emphasize the contrast of places in which there is a dark area (in this case the edge of the ear's cast shadow) right next to a light area. Now your portrait of Robert is complete.

Robert
8" × 6½" (20cm × 17cm)

Demonstration Portrait Four: Tami

For Tami's portrait you will use Burnt Umber, Burnt Sienna, Cobalt Blue and a tad of Rose Madder Genuine to paint her earring. Your base flesh tone for Tami's bronze skin will be the Burnt Umber, which you will modify with the Burnt Sienna and Cobalt Blue. As always, read through the demonstration first and familiarize yourself with the color relationships before you undertake the actual portrait. This portrait will again require three watercolor round brushes and surfactant.

Palette
Burnt Umber
Burnt Sienna
Cobalt Blue
Rose Madder Genuine
Your base flesh tone is Burnt Umber, which you will modify with the Burnt Sienna and Cobalt Blue.

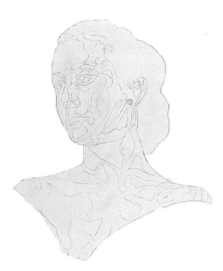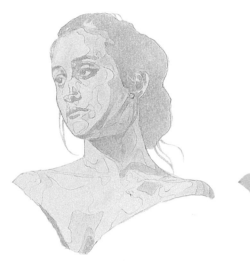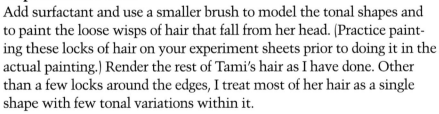

Step 1: Tone Form
With a large brush, apply a flat wash of Burnt Umber with no surfactant.

Step 2: Model Forms
Add surfactant and use a smaller brush to model the tonal shapes and to paint the loose wisps of hair that fall from her head. (Practice painting these locks of hair on your experiment sheets prior to doing it in the actual painting.) Render the rest of Tami's hair as I have done. Other than a few locks around the edges, I treat most of her hair as a single shape with few tonal variations within it.

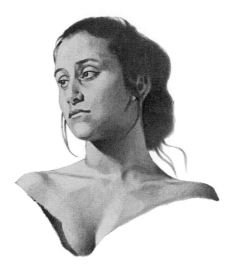

Step 3: Introduce Cool Modifying Tone

Use a large round brush to lay in a light wash of Cobalt Blue without surfactant over the entire form. Then switch to a medium-size round brush and add the surfactant. Use this blue to further darken the shaded parts of her form. Use it to darken and tone down her hair as well. Add faint glazes of the blue to the *halftones*—the intermediate zones. These are the surface planes that are oblique to the source of light but not quite on the shadow side. You can see what I mean in my example.

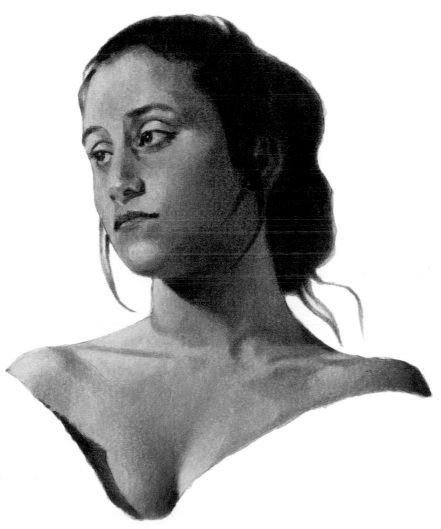

Step 4: Introduce Warm Modifying Tone

Now bring in the Burnt Sienna. Use a large round brush to lay in a pale flat wash without surfactant over the entire form. Then, with surfactant, use a medium-size brush to glaze over the parts of her flesh that are pinkish from the blood showing through, such as her cheeks and the upper-middle part of her chest. Use it to paint the vermilion part of her lips. Then use a dot of Rose Madder Genuine to paint the visible part of the earring. This little bit of red, which occurs nowhere else in the painting, serves as nice accent color. Do any lightening that you deem necessary, which will make this portrait complete.

Tami
9" × 7½" (23cm × 19cm)

Demonstration Portrait Five: Lauren

The Chameleon Effect

In the portrait of Lauren, you will paint a close-up of her face. This will give you a more personal view of her face, where I will show you how to paint her charming freckles. The base tone here will be a warm, earthy red, over which you will glaze two augmenting overtones: a cooler red and a yellow.

In this painting you will have a simple background to paint. You will learn how to use the *chameleon effect*, which refers to the tendency of the flesh tones, hair, clothing, etc. to take on the colors of their surroundings. This phenomenon occurs in nature, but most people never notice it because it is so subtle. But if you leave it out of your portrait painting, the figure won't look quite right. It will have a "pasted on" appearance because the subject will not look like it belongs in the same painting as the background. Keep in mind that you, as the artist, have the creative license to improve upon both nature and photography. You can amplify and exaggerate the chameleon effect. In this case, by the way, the background color will also serve as the countertone to the base flesh tone. You will need three watercolor rounds and surfactant.

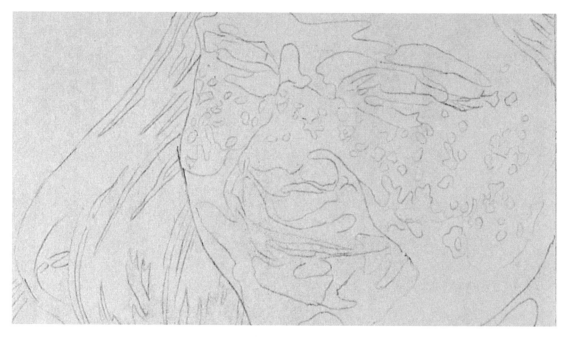

Step 1: Tone Form
Using a large round brush, lay in a flat wash of Burnt Sienna without surfactant over the entire rectangle.

Palette
Burnt Sienna
Yellow Ochre
Rose Madder Genuine
Indanthrone Blue
New Gamboge

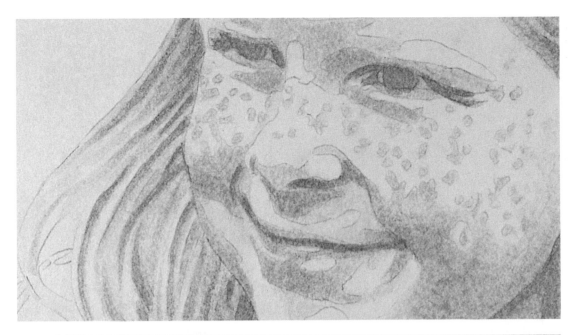

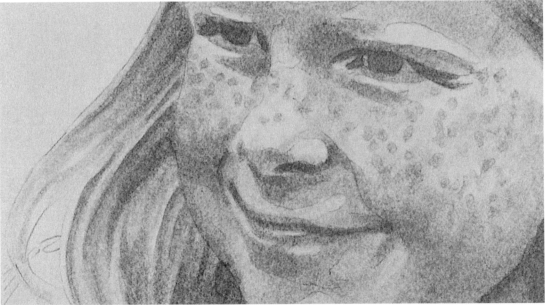

Step 2: Model Form

Switch to a small round brush and add surfactant to your watercolor solution. Use it to both model the forms and paint the freckles to the extent that I have done in my version. Define the tonal shapes in the hair in the same way you define any other form, by the contrasts of lights and darks. In this case, the contrasting tonal shapes are simply long and narrow. You are using more definition in the hair than you have in the previous portraits; but don't try to paint every single hair. Don't even try to paint every minute lock of hair that you see in the photograph. Just do the major ones.

Step 3: Apply First Overtone

Now add the Yellow Ochre overtone, but not over the entire picture. Apply it selectively. Glaze it over her hair and eyebrows, which will make them look like the color of natural red hair. Glaze a bit of it over the left side (the side on our right) of her face and neck. This suggests the reflected light that is bouncing off her hair and onto her skin. (Reflected light is always the same color as the object from which it is reflecting.) Soften the hard edge of the hairline at her temple in the same way you softened a rim line in chapter 5 (see page 72).

Step 4: Apply Second Overtone

With your large brush, lay in a wash of Rose Madder Genuine without surfactant over the entire picture plane.

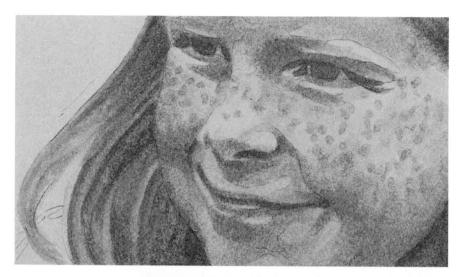

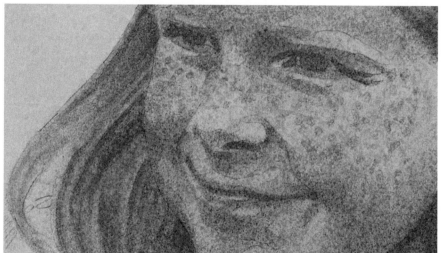

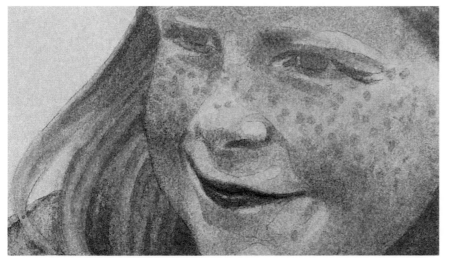

Step 5: Develop Flesh Tones

Add surfactant to the Rose Madder Genuine and use it to paint her shirt and her lips. Glaze a little extra of it on her cheeks, chin and forehead, as well as the areas just under her eyes and under the inner part of her eyebrow. Also glaze it into the darker parts of her hair next to her right chin and into the darker shadow area under her left jawline.

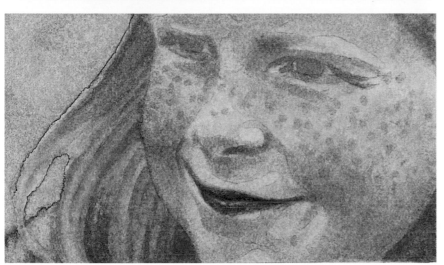

Step 6: Paint Background

First, paint the background itself with washes (without surfactant) of Indanthrone Blue and Yellow Ochre. Don't mix these pigments, though. Put in a wash of pure blue with a medium-size round brush. Then immediately—while it is still fully wet—add the pure yellow to it. (The yellow paint should not have surfactant in it.) Do this by dipping the same brush (after you have rinsed the previous blue paint out of it) into the solution of the Yellow Ochre. Then drop some of the yellow into the blue at selective places by letting the tip of the brush barely touch the wash that is already there. This will cause some of the yellow solution to run down into the blue wash.

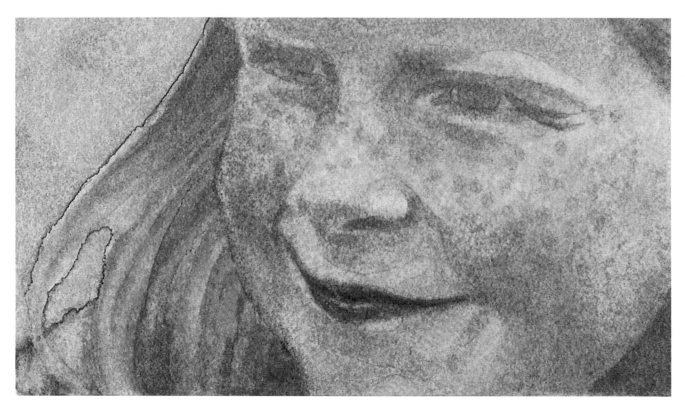

Step 7: Introduce Chameleon Effect

When the background has dried, make a diluted wash by mixing Indanthrone Blue and New Gamboge—still without the surfactant. Apply this wash to the entire face and hair, including the darker area beneath her left jawline. Then add surfactant to the mixture and glaze some of it into the flesh tones selectively. Paint some of it across the forehead, the underside of the nose, the cheeks and jawlines and the areas under the eyes. In my version, I have also begun doing a little bit of lifting to heighten the lighter areas.

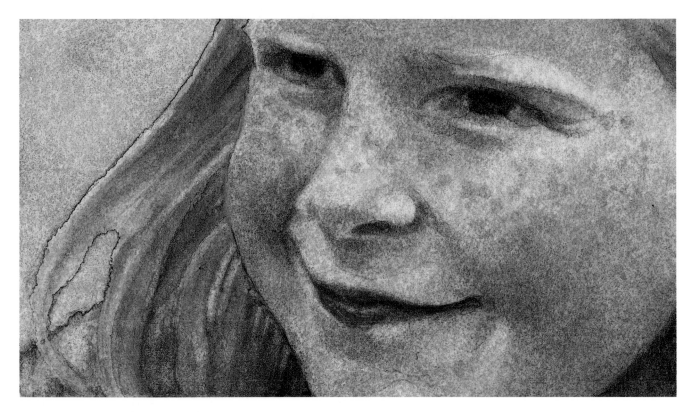

Step 8: Add Finishing Touches

Now you can use pure Indanthrone Blue with surfactant to finish painting the darkest parts of the face and hair. In my version I have added some more Burnt Sienna to the hair. I have redistributed the colors in lower cheek areas by using circular motions with a wet (but not sopping wet) round brush. This is a technique that can work very well in a situation like this. I have also done some final lifting. You may wish to make similar adjustments in your own version—but don't do it just because I have done it. If you like the way your painting looks as it is, leave it that way.

Lauren
3¼" × 5½" (8cm × 14cm)

Demonstration Portrait Six: Chuck

For Chuck's portrait, you will return to your very first flesh-tone palette. Your base flesh tone will be the mixture with which you painted Robert. You will use this color blend to paint the facial hair as well. This time, in addition to your three watercolor rounds, you will also need two flat brushes. No surfactant is needed this time, though. You will be modeling this portrait with bolder, more decisive strokes.

The photo of Chuck on page 62 gives you a general idea of his flesh-tone range. But the colors in the photograph are not accurate enough for you to try to match them, so I will show you how to work around this obstacle. You will also discover the broad artistic license that you have when painting flesh and hair tones.

Palette
Rose Madder Genuine
New Gamboge
Cobalt Blue
Your base tone is a mixture of Rose Madder Genuine and New Gamboge.

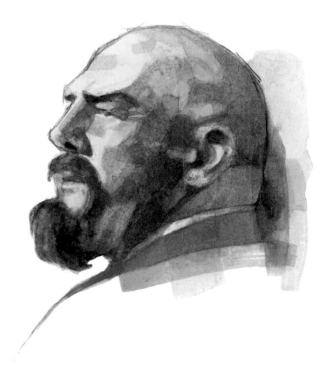

Another Version

This is a second version that I did of Chuck Fuchser using the same palette that I used for the following demonstration. I did this after completing the other one because I wanted to see if it would be better to have you paint his facial hair as dark as it is in real life. And that was important enough to me to spend the extra time to do the same portrait all over again. After comparing the two paintings, I decided that I liked the second one better. But I felt that the first one was best for the demonstration. I am showing it to you now to reinforce a point that I have made before: Most professional artists are not hesitant to do the same painting over again from scratch, if that is what it takes to get it right. This is part of being a conscientious artist—particularly when you are new at it and learning how to do it.

Step 1: Tone and Model Form

Begin your painting of Chuck with a light wash of your base flesh tone without surfactant. With a medium-size round brush, fill in the entire head, including the facial hair, and let some of it go a little beyond the back of his head and neck.

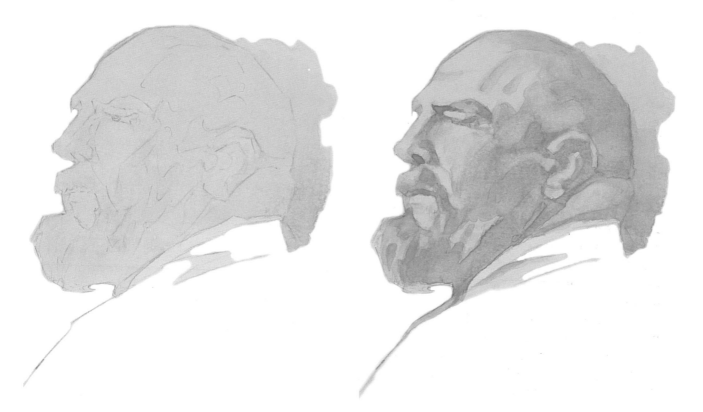

Step 2: Model Form

Add surfactant and, with the retouching round, use the flesh-tone wash to establish the major tonal shapes of the head and beard. As you do, occasionally carry more of the flesh-tone mix out behind the head. Paint the beard the same way you paint every other part of the head. Regard it as a single shape that is defined by the contrasts of tonal values. It may not seem like this would work, but it will.

Step 3: Split Flesh Tone

Now you can *split* the flesh tone by bringing in its component colors—Rose Madder Genuine and New Gamboge— separately. Use the Rose Madder Genuine to further darken the lower tonal values. Layer the New Gamboge into the broadside planes of the head— those that are perpendicular to our line of sight. This will serve as a yellow reflected light that will make the skin surface more interesting and lively. Try using your flat brush to paint some of the tonal shapes. Try to do as many of them as you can with single strokes. You can find examples of such strokes in my version—the one on the edge of Chuck's forehead, for example. You should have practiced this type of brush-stroke before you began this painting, so you ought to have some idea of what to expect from these strokes. Yet, if you still fear that you might accidentally make a bad stroke, play it safe: keep a crumpled sheet of paper towel handy to dab the paint out immediately before it dries. Then allow the surface of the board to dry before you try it again. Sometimes let the red and yellow over-lap the back of Chuck's head.

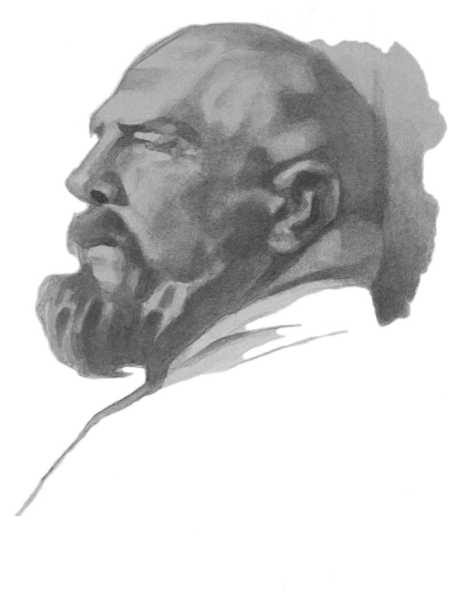

Step 4: Add Finishing Colors

For the finishing touches, bring in the Cobalt Blue. Continuing to use single brushstrokes as much as you can, layer the blue into the very deepest of the tonal shapes. Glaze some of it over the surface planes to the right of each of the ones that you have already painted yellow. This will appear to be more reflected light coming from a different direction. (Look at my version to see what I mean.) And layer some over the receding planes at the back of his head, again letting some of it spill over. Leave the back part of his neck at the base of his skull lighter than the back of his head to suggest some reflected light from an unknown source behind him. Use the blue for his eye and coat collar. Blend some of it with the Rose Madder Genuine for the shadow that falls on the front of his white shirt collar. And finally, for consistency, lay some of the New Gamboge into the parts of his shirt and coat collar that correlate with the yellow planes of the head. Likewise, paint some extra blue in the collars that coordinates with the blue planes of the head. You can see what I mean in my illustration, in which I have painted some of the New Gamboge with a single downward stroke of my flat brush. This completes your portrait of Chuck.

Chuck
6½" × 5½" (17cm × 14cm)

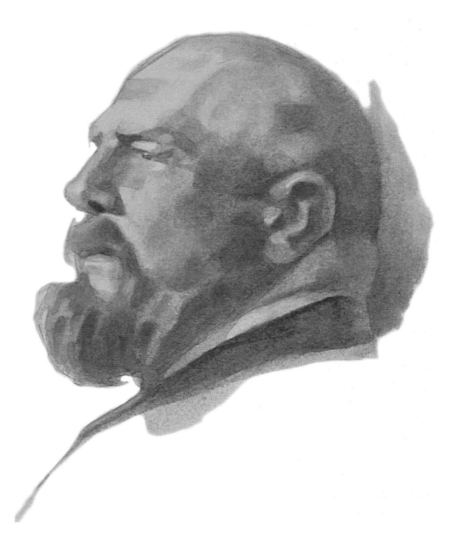

Pause and Review

Before proceeding to the next portrait, pause to review what you have done up to this point and see what you have accomplished. Lay the previous portraits out on a flat surface or—better yet—lean them up against something. Assess your progress. Then compare the painting of Chuck to the photo that you did it from. You have not just imitated the reference photo; you have gone well beyond the limits of photography and even real life. You used

your artistic license and skill to improvise the flesh tones. Look at the variety of flesh tones that you have achieved in this portrait with just three pigments. Notice how you have augmented the sense of mass and volume using the contrasts of color and tonal values. Your painting is much more vivid, vibrant and vivacious than a photograph—or even real life—could ever be. This is the kind of thing that makes you an artist.

Demonstration Portrait Seven: Liz

Your portrayal of Liz will be somewhat more involved than the previous portraits. I will therefore divide it into three separate demonstrations. In this portrait, I will challenge you with compound flesh tones and a more complex watercolor painting technique called *wet-into-wet*. This project will introduce you to the kind of flesh-tone formulations that many professional watercolorists use. You will work with five pigments and have four flesh-tone mixtures. Because the portrait image itself is already complicated enough, I have again left out the background.

You will also need granulation medium, surfactant and three round brushes. I suggest that you read the entire demonstration, study the step-by-step illustrations and practice the techniques thoroughly before undertaking this project.

Palette
Alizarin Crimson
New Gamboge
Burnt Sienna
Cobalt Blue
Burnt Umber

Your flesh-tone mixtures are:
Alizarin Crimson and New Gamboge
Alizarin Crimson and Burnt Sienna
Alizarin Crimson with a touch of Cobalt Blue
New Gamboge with a touch of Cobalt Blue

Part One: The Face, Neck and Shirt

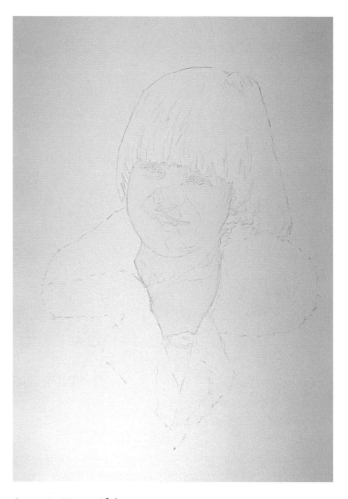

Step 1: Tone Skin
Using a medium-size round brush, lay in the initial light toning wash of the Alizarin Crimson/New Gamboge mixture over all the skin areas. This will serve as the base flesh tone for the areas of skin that are in the sunlight.

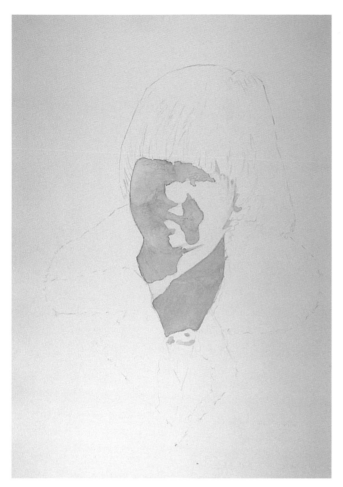

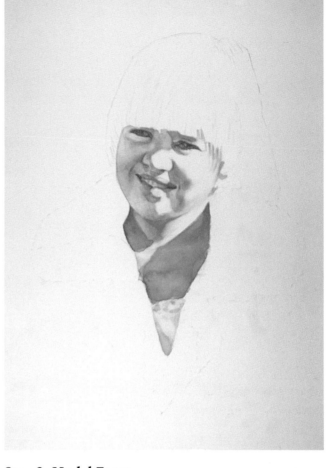

Step 2: Create Flesh Tones

Once the initial toning wash has dried, you are ready for the other three washes. Lay a wash of the Alizarin Crimson/Cobalt Blue mixture into the shadow areas of her left eye, the right side of her neck and the upper corner of the cast shadow falling across the lower left side of her neck. Lay in a wash of the Alizarin Crimson/Burnt Sienna mixture over the remaining shadowed areas. Let the washes of these two flesh-tone mixtures touch each other, and let them interact with each other as they may. Immediately, while these two washes are still wet, bring in the New Gamboge/Cobalt Blue mixture. Drop it into the shaded areas that turn toward her right side—at her right eye and upper cheek, the right side of her chin and the inner part of her left cheek. As these drops of color hit the previous wash, they will spread out and intermingle with the other neighboring colors. Don't panic; this is what you want it to do. And because the results are so unpredictable, don't expect yours to look just like mine. When the washes have dried, use a moist brush to soften the edges of all the shadows that are not cast shadows.

Step 3: Model Form

At this point, add the surfactant to the Alizarin Crimson/Cobalt Blue and Alizarin Crimson/Burnt Sienna combinations and use them to model the facial features and other flesh surfaces. In the darker areas of the eyes and mouth, use the Burnt Umber.

Use pure Cobalt Blue to paint the material of Liz's blouse. There are some places on the lace border of the blouse through which her skin color should show through. You can get that see-through effect by glazing those spots with the Alizarin Crimson/Burnt Sienna mixture. Glaze some of the Alizarin Crimson/Cobalt Blue mixture over the shadow in the V-shape corner at the bottom of the collar. This helps that shadow to harmonize with the warm colors above it. Glaze pure Cobalt Blue over the left side of the bridge of her nose, the left side of her jawline and the left side of the bridge of her upper neck (under her chin). And add a touch of it to the very edge of her left ala (the outside "wing" of the nostril) and under her left clavicle (collarbone). With this done, you are ready to move on to the collar.

Part Two: The Fluffy Collar

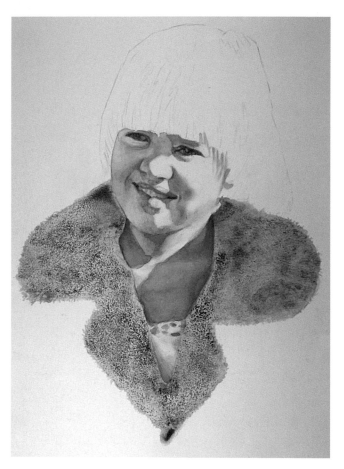

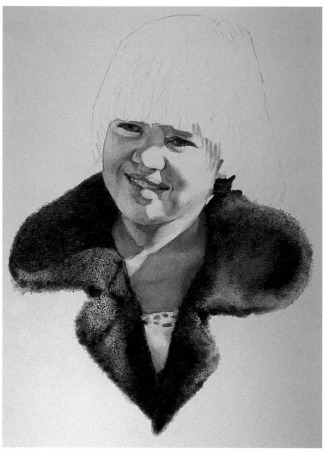

Step 4: Create Fluffy Texture
Dilute some of your Burnt Umber, right out of the tube, with granulation medium. Use pure medium, without water and without surfactant. Test it thoroughly on your experimentation sheet to make sure you will get the effect that you want. Then use it to paint the coat. In my demonstration version above I have laid in a single, relatively diluted wash to give you an idea of what to expect.

Step 5: Model Collar
Develop the tonal values in the collar—the shapes of shadowed areas—with additional layers of Burnt Umber in granulation medium.

A Tip for Using Granulation Medium
When applying the Burnt Umber, the granulating pigment may not disperse itself as evenly as you would like. It may, for example, follow the tracks of the brushstrokes. You can redistribute the pigment. Immediately after laying in the wash (while it is still quite wet) lean down beside the painting and gently blow the paint around.

Part Three: The Hair

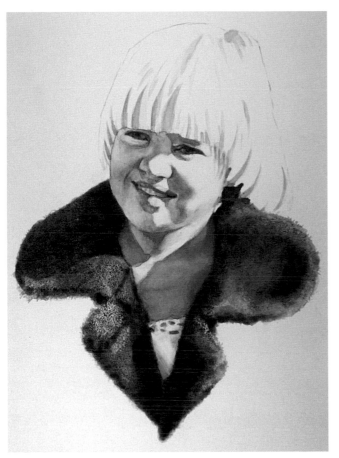

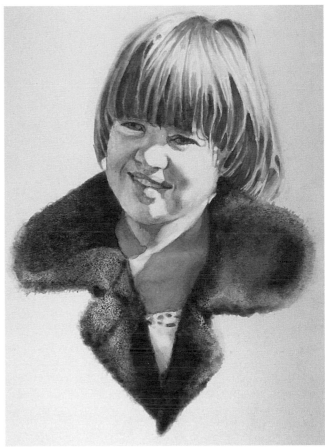

Step 6: Tone and Model Hair

Use Burnt Umber to paint the hair. First tone the overall shape of the hair with a wash without surfactant added. (Dilute it with *pure water* for this step, with no granulation medium.) Then add the surfactant and begin developing the tonal values. The best way to model the hair is to paint the dark areas between the locks of hair. Don't try to paint them all,however; just the major ones.

Step 7: Finish Hair

Continue modeling the hair to the extent that I have in my demonstration. Avoid overworking it which can happen very easily. When you have finished the hair, your portrait of Liz is complete.

Liz
12" × 8½" (30cm × 22cm)

Demonstration Portrait Eight: Ben

With Ben's portrait, I will introduce you to some new visual elements. You will paint more of a background—but it will be an abstract background. To do this, you will again use the *wet-into-wet* technique. Your palette will consist of just two colors: Cobalt Blue and Quinacridone Sienna. This painting will require no pigment mixing.

For your brushes, you will need three rounds and a ½-inch (12mm) flat. You will also use your liquid frisket But you will not use your surfactant this time. You will be more direct in your modeling of the tonal values, with less cautious layering and much bolder strokes. You will still have the underdrawing to guide you, but you won't be so obligated to stay entirely within its bounds.

Palette
Cobalt Blue
Quinacridone Sienna

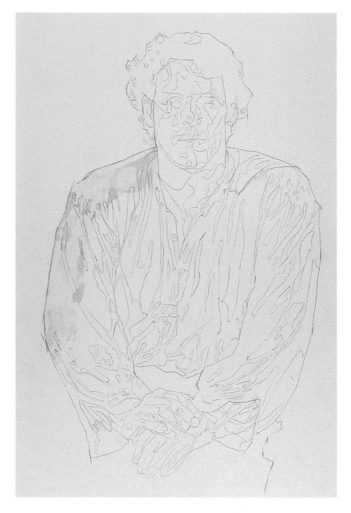

Step 1: Apply Masking Fluid

To prepare this underdrawing for painting, you must first apply the masking fluid. You can use your no. 6 Isabey retouching round to apply the masking fluid. (If you have another, less expensive small round brush, you may wish to use it instead.) To protect your brush from getting the masking fluid deep into the base of the brush hairs—where it may be hard to get out—I recommend a precautionary step. Get an ordinary bar of hand soap. Then wet the brush and gently work up a lather of the soap in the brush hairs. This will act as a barrier that will shield the brush hairs from the fluid.

Paint a margin of masking fluid on the inside edge of the outer contour of Ben's right arm. Make sure it is wide enough to guard the image from the strokes of your brush as you paint the background. When it dries, you are ready to do the first step: the background.

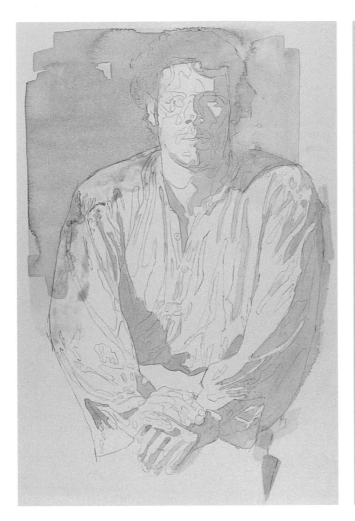

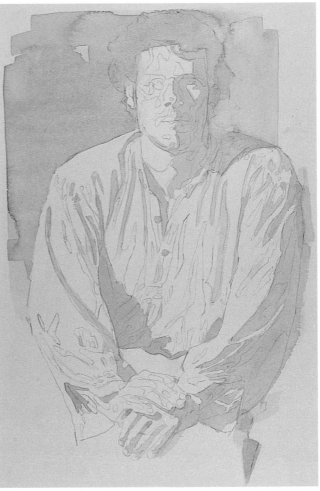

Step 2: Paint Background and Shadows

With your ½-inch (12mm) flat brush, lay in the background with washes of Cobalt Blue and Quinacridone Sienna. Use up-and-down and side-to-side strokes. Start with the blue and while it is still fully wet, brush some strokes of the Quinacridone Sienna right into the previous blue wash. The results of this approach are not entirely predictable. Nevertheless, if you have practiced it on your experimentation sheets you will know how to get the overall effect that you want. Then loosely block out the major darker tonal shapes in the figure. Use the lines of the underdrawing to guide you, but let your actual brushstrokes be free. Take a look at the lower right side of the painting where I have placed a couple loose, downward brushstrokes to prevent the appearance of the top half of his body floating in the air.

Step 3: Remove Masking Fluid

When the paint has dried completely, remove the masking fluid. It is now a rubbery layer that can be peeled off. As you do this, be careful not to smear the paper with the paint that has settled on top of the film. Then restore the lines under the masking fluid that probably were lifted off when you removed the fluid. Next, paint those tonal shapes to match those that you have already done. I noticed that I missed two buttons in the previous step, so I also take care of that now. Also lift out any of the background wash that may have crossed over the pencil lines and invaded an area where you don't want it. But remove a crossover *only* if you think it detracts from the overall painting. Otherwise, just leave it there, where it will add to the spontaneous feel of the painting.

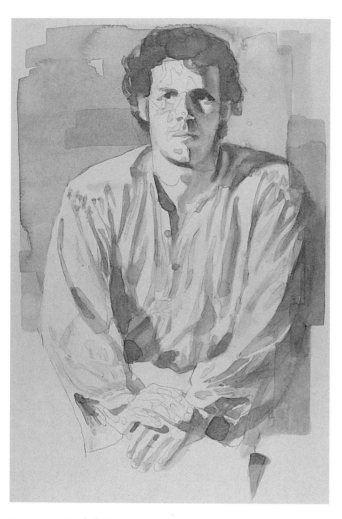

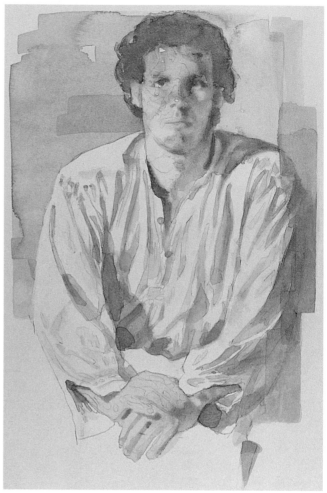

Step 4: Model Forms

You can now use the Cobalt Blue to model the tonal values, but don't use any surfactant with it, and don't be too meticulous with your brushstrokes. As the painting evolves, keep checking to see if you need to make any adjustments. In my painting of Ben, I have added a horizontal brushstroke of blue to the area on the right side of his face. And I have added four vertical brushstrokes of the blue over the edge of his left sleeve. These are judgment calls that I have made for purely compositional reasons. I think they add better balance to the picture, and the one to the side of his face seems to make his head stand out more. You may decide to make such discretionary adjustments yourself. Don't do it just because I did, though—do it only if you think your own painting needs it.

Step 5: Introduce Warm Tones

Bring in Quinacridone Sienna. Use a flat wash to tone all of the surfaces of the skin and hair.

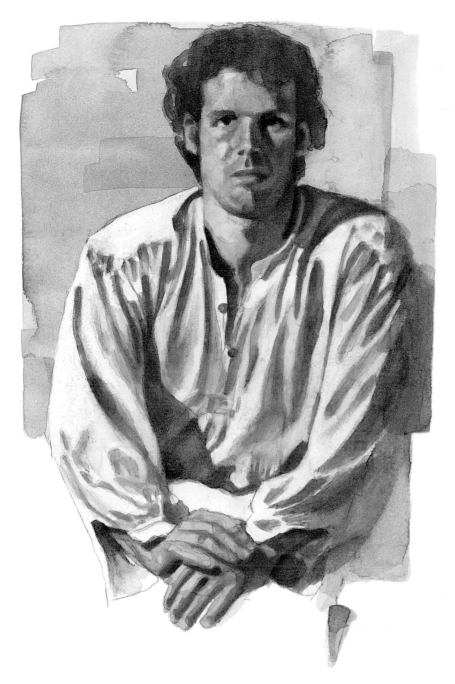

Step 6: Do Final Modeling and Add Finishing Touches

Use Quinacridone Sienna right over the top of the blue underpainting to finish modeling the forms. As the painting has evolved, I have decided to place some brushstrokes of Quinacridone Sienna on top of some previous blue brushstrokes. You will find them over the edge of his left sleeve and on top of the small discretionary blue stroke in the lower right-hand corner of the picture. And I have placed a third one at the side of his right elbow. I have also lightened up some areas, especially on the white shirt. By now you know how to do that, and—if you think it's necessary—can do the same to your own painting. Now, congratulations! You have finished the last painting in this book. Don't go away though, until you have read the conclusion.

Ben
12" × 8" (30cm × 20cm)

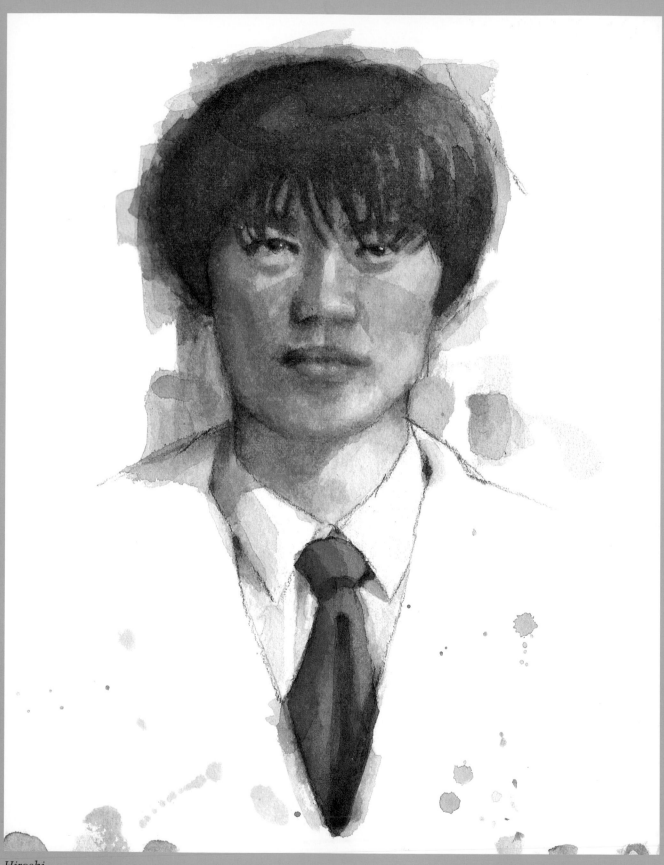

Hiroshi
10" × 7" (25cm × 18cm)

CONCLUSION

When you have finished this book, my best advice to you is to keep going. There is a wide, wide world of figures and faces out there for you to paint. Experience is the best teacher. And it will require practice for you to get as good as you want to be. Do some paintings of your own. If you want to work from photographs, try to find some (or shoot some yourself) that you could paint in the same way that you did one of the paintings in this book.

If you are not already proficient in your drawing skills, I urge you to take a beginning drawing class and/or workshop. You cannot do successful watercolor paintings of people or portraits unless you can render a successful underdrawing. And you should take a class from an instructor who teaches old-fashioned drawing techniques in which you learn to accurately render your models. The "responsive" and "interpretative" approaches won't help you much here. You would, by the way, probably get your best instruction from a professional artist. I say this because there are many professors and instructors in the academic system that have degrees in art—but no professional skills. And they can't teach what they don't know.

You may wish to take workshops on watercolor figures and portraits, too. Watercolor workshops in landscape and still life would teach you how to do the backgrounds in your paintings. Again, though, study with competent artists/instructors rather than merely teachers with degrees.

There are excellent books and videos on the market by some of the best professionals. North Light publishes several of them. Broad exposure to different artists, writers and instructors can take you in new directions and help you explore and develop a style of your own.

Index

Find More Great Painting Inspiration with North Light Books!

Paint more lively, inspiring landscapes with the creative use of reference photos—where magical moments of light are frozen in time and gorgeous winter vistas can be painted from the comfort of your own studio. Dozens of examples and step-by-step demonstrations show you how to shoot good reference photos, then crop, modify and combine elements from each for stunning landscape paintings of your own design.

ISBN 1-58180-973-1, HARDCOVER, 128 PAGES, #31524-K

Charles Reid is one of watercolor's best-loved teachers, a master painter whose signature style captures bright floral still lifes with a loose spontaneity that adds immeasurably to the whole composition. In this book, Reid provides the instruction and advice you need to paint fruits, vegetables and flowers that glow. Step-by-step exercises help you master techniques for painting daffodils, roses, sunflowers, lilacs, tomatoes, oranges and more!

ISBN 1-58180-027-4, HARDCOVER, 144 PAGES, #31671-K

Overcome the elusive challenge of rendering realistic skin tones in your portraiture. Whether your subject is Caucasian, Asian, African-American or Hispanic you will find practical guidance to successfully depict each one's distinct beauty. Lessons and demonstrations in oils, pastels and watercolors teach you how to mix colors, work with light and shadow and edit your compositions for glowing portraits you'll be proud of.

ISBN 1-58180-163-7, HARDCOVER, 128 PAGES, #31913-K

Exercise your artistic creativity by starting your own sketchbook journal. More than a diary, it's a personal private place to express yourself, experiment, discover, dream and document your world. Popular artist Claudia Nice shares beautifully illustrated examples from her own journals and provides you with practical advice and tips for keeping your own. You'll learn effective techniques for using pencils, pens, ink and watercolor in everything from travel journals, garden journals, field sketches and more.

ISBN 1-58180-044-4, HARDCOVER, 128 PAGES, #31912-K

These books and other fine North Light titles are available from your local bookstore, online supplier or by calling 1-800-221-5831.